CLOSE-UP
PHOTOGRAPHY
IN PRACTICE

CLOSE-UP
PHOTOGRAPHY
IN PRACTICE

Axel Brück

DAVID & CHARLES
Newton Abbot London

An Element Technical publication
Conceived, designed and edited by
Paul Petzold Limited, London.

First published in 1984

British Library Cataloguing in Publication Data
Brück, Axel
 Close-up photography in practice.
 1. Photography, Close-up—Amateur's manual
 I. Title
 778.3'24 TR683

 ISBN 0–7153–8403–1

Designer Roger Kohn
Illustrator Janos Marffy

Typeset by ABM Typographics Limited, Hull
and printed in Great Britain
by Jolly and Barber Ltd., Rugby
for David & Charles (Publishers) Limited
Brunel House Newton Abbot Devon

CONTENTS

1 CLOSE-UP: MEANS AND METHODS

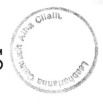

At one time taking pictures close-up presented real difficulties to the photographer. Even a decade or two ago special equipment for this kind of work was hard to find and, if available, was expensive, cumbersome and problematical to use. Many people seem to believe that these conditions still prevail.

However, today the quality and versatility of photographic equipment and materials has reached a stage of development where it is possible to take many kinds of close-up photograph without any special knowledge or mechanical aids. At the same time, highly sophisticated close-up equipment has come on to the market which, although a bit more difficult to handle, allows the average photographer to achieve things that only a few years ago would have been completely beyond his scope.

Close-up photography of some kinds can be just about as easy and inexpensive as you could wish because it is possible to do many interesting things with the equipment you use for general photography—perhaps with the addition of a simple and inexpensive supplementary close-up lens or an extension ring. At the opposite extreme to this are complete macrophotography units for very specialised applications that can cost as much as a small car! Fortunately, such hardware is nowhere near a 'must' for good results. You can do everything that this can do without spending a fortune if you are prepared to invest the necessary thought and labour.

The most important thing is to know what kind of equipment to use for each purpose, and how to handle it correctly. In this book I have confined myself only to information that is of practical value and essential to developing or extending your skills in close-up work. Throughout, I have had photographers like myself in mind rather than those who garner information for its own sake. This practical information falls roughly into four categories:

1 Definitions and explanations of close-up photography in general. Most of this is discussed along with the equipment or techniques to which it relates. But some of the common problems, mainly of concern to the advanced specialist, have been gathered together in the first chapter.

2 Equipment. I have taken care to describe the various kinds of equipment that can be used in close-up work, explaining its use and handling and what to expect in the way of results. Close-up is probably the area of photography with the greatest concentration of useful or essential hardware and a book exploring the many byways of the subject necessarily concerns itself extensively with this aspect. Therefore, the hardware, its usefulness or shortcomings, improvisations possible to obtain particular results and the handling of these means to an end form the main body of the text. I have not, however, attempted to compile a complete catalogue of available close-up equipment. Such information can be obtained in printed form and often free of charge from the makers of the hardware themselves. I have only mentioned the more out-of-the-way or unique items when they offer special advantages. Although too expensive or difficult to obtain, they nevertheless serve to highlight the problem and may even inspire some form of effective improvisation on the part of the reader. I have suggested a number of such home-made remedies based on my own experiences of the problems. The reader should always bear in mind that, as in other branches of photography, there is rarely an absolutely 'right' or 'wrong' way of doing anything. I have simply suggested the most convenient or effective way that I have found of doing things and what I have said is based entirely on my own first-hand experience and methods developed over the years.

3 Subject matter. The latter part of the book contains suggestions about tackling individual subjects, what kind of equipment is suitable and how you can set about taking your pictures. You may, of course, read this part first and then refer later to the equipment or techniques that interest you.

4 The creative approach. Throughout the book I have paid special attention to the problems of

1 Magnification 0.9 X (1 : 1.11), f/16, flash, 100mm macro lens, hand-held camera, windshield used to reduce the plant movement and keep it within the focus depth and field of view.
2 This silhouette of a spider with its prey is a typical example of the type of creative close-up work described in the text. The spider was living between two glass panes and the picture was taken from indoors against the sky background. Magn. 0.8 X f/11, 1/125 sec, 100mm macro lens, hand-held camera.

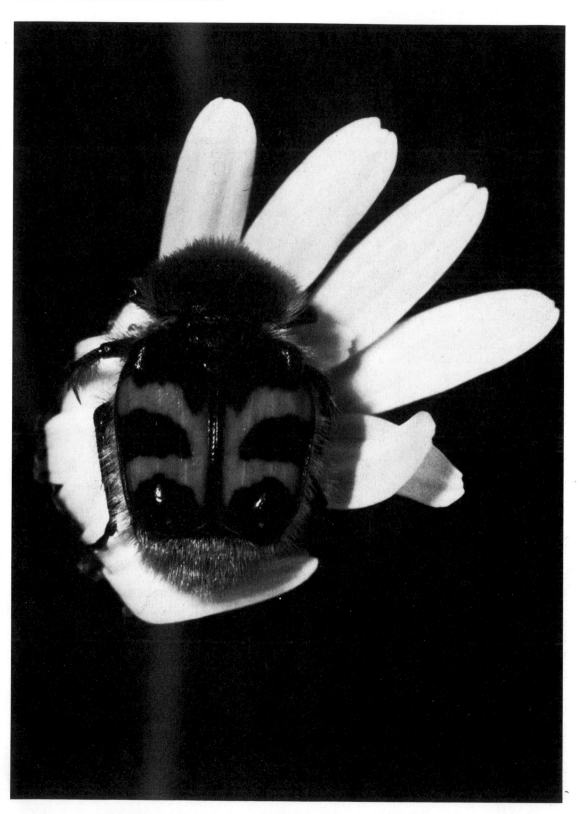

creative close-up photography. Although not treated as a separate subject area it is nevertheless, to my mind, of the utmost importance.

Scientific (documentary) photography is a means of imparting information in a form which is understandable and legible to members of the scientific 'community'—nothing else. But for a non-scientist, a close-up photograph serves the same function as a 'general' picture. It can be aesthetically pleasing, it may convey moods or feelings to others, or it can be an essay in formalisation. Whatever it is, or whatever you want it to be, your photograph has to succeed as a pictorial statement—and this is where the creative approach comes in.

This creative approach is reflected in all aspects of close-up photography other than the production of pure records, from the choice of equipment through to the choice and treatment of the subject matter.

You might, nevertheless, be more interested in the documentary approach to close-up photography because you want to reproduce, say, your stamp or coin collection, or your miniature trains, or because you are what is sometimes referred to disparagingly as an 'amateur scientist'.

Let us stay with the non-scientific aspect a little longer. I am not a scientist. If I photograph an insect or a plant, I am not primarily interested in what it is, or whether it is very common or rare. I am more concerned with the subject matter itself, its beauty or the mood or feeling that I can convey by taking a picture of it in a certain way. Although the technical approach is the same, this is obviously no way to take scientific photographs. I might, for example, decide to show some part of my subject matter out of focus for some compositional reason or other. While this is completely justified in terms of the creative approach, it would never do when making a documentary photograph. You yourself will have to decide what kind of picture you want—the ways and means to realise it are described in this book.

When choosing illustrations, I have always preferred the creative realisation, because I believe that most people soon wish to develop their close-up work beyond the range of pure craftsmanship. Apart from that, I have tried to stress unconventional subjects. Butterflies and roses are what might be termed 'self-evident' close-up subjects, so I have introduced some possibilities which are a bit more out-of-the-way.

Taking a close-up photograph is one part of the job; finding an interesting subject can be quite a problem of its own. Combining the right technical approach with this subject matter so that you end up with a fascinating photograph is what we are going to investigate in this book.

Basics for close-up

It is not very often that an author suggests that you need not read the first chapter in his book. But its value to you depends very much on how well-equipped you are. You can, of course, take first-rate close-up photographs without knowing anything about definitions, formulae and optical laws.

Some of today's hardware is so sophisticated that you can use it successfully without reference to much of the information contained in this chapter. You should have a look at the paragraphs below where close-up photography is defined and also the remarks on magnification. You can safely skip the rest because those problems and basics which are directly related to some piece of equipment or other or to a special technical point will be discussed later on in the appropriate chapters. However, it is quite possible that you have to make do with relatively simple or old-fashioned hardware or that you want to try something unusual and technically out-of-the-way. If so, this chapter is for you.

What is close-up photography?

There has been, or perhaps still is, some confusion concerning the term 'close-up photography', although the definition is actually quite simple. The range covered by close-up photography starts with magnifications of 0.1 x (one-tenth life size) and ends with magnifications of 1 x (life size), while macrophotography (the popular word, though more correctly, 'photomacrography') is the term commonly applied to magnifications of between 1 x and 10 x (ten times larger than life size) or, in some instances, up to 20 x or greater.

The confusion arises out of the fact that in everyday language the term 'close-up photography' covers the whole range of magnifications from 0.1 x to 10 x.

I am not going to be dogmatic about this business of definitions but you will see later on that this division of the whole range into two parts (close-up photography and macrophotography) serves a practical purpose, insofar as it neatly coincides with different requirements in equipment and technique.

As far as the scope of this book is concerned, I will deal with both ranges of close-up photography and also have a look at photography at magnifications of greater than 10 x, which is usually termed photomicrography. I think that this is profitable and legitimate because certain kinds of 'macro' equipment can be used for magnifications of up to 30 x.

Magnification

In the preceding paragraphs I have made free use of the term magnification, which we will have to investigate next because it is the key to understanding close-up photography.

Magnification defines the relationship in size between the object you photograph and its image on film. Ironically, the word 'magnification' may be applied to an image on the film which is actually smaller than the original subject and is therefore strictly a reduction. In close-up work it is the standard term for what is, in effect, the *ratio of*

reproduction between the subject and its image on film. It can be expressed numerically in different ways, which all mean the same thing.

'Natural size' or 'life size' means, for example, that the object and its image on film are of the same size. Numerically this is expressed as 1 x magnification, or 1:1, or even 1/1. For the three main categories of close-up photography this works out as:

Magnification: ten times smaller than life size
0.1 x 1:10 1/10
Magnification: life size or natural size
1 x 1:1 1/1
Magnification: ten times larger than life size
10 x 10:1 10/1

3 Documentary pictures usually require maximum sharpness, depth of field and clarity of detail to give the greatest possible information about the subject. At close range, even the relatively low-powered ring flash such as that used here makes this task easier by combining a small aperture with very short exposure. 55mm macro lens.

I will stick to the most common of these usages, which is that shown in the first column of this table. If you find an indication of magnification plainly stating 'magn. 7 x', this always refers to the size of the image on *film*. If you want to indicate the relationship between object size and print size (or reproduction size) you will have to say so explicitly. In order to avoid confusion, this relationship should not be called magnification, but *enlargement*.

The distinction may seem unnecessarily cumbersome to you, but the perfectly valid reason for it is that a photographer does not necessarily know beforehand at what size his picture is going to be printed as a photograph in, say, a magazine. Another reason for occasional confusion is that you may not know the negative size involved. Yet without this data, you cannot draw any conclusions as to the actual size of the object depicted.

If you are told that a particular photograph has been taken at a magnification of 1 x, this could, for example, mean that the object was 9 x 12 cm (when taken with this format) or 24 x 36 mm (when taken with a 35mm camera). Therefore a complete description of a close-up photograph should contain the following information: (a) negative size used (b) magnification on film (c) degree of enlargement for print.

Nowadays, if the negative format is not mentioned, you can fairly safely assume that a photograph has been taken with a 35mm camera, because this has become easily the most popular close-up equipment. (Where negative format is not mentioned in the description of illustrations in this book, it is always 35mm.)

The following table shows the relationship between magnification and object size, based on the dimensions of the 35mm format. (In practice there may be very slight differences, because not all cameras have an available image area measuring exactly 24 x 36mm!)

1.1 Magnification and object size (35mm)

Magnification	0.1	0.2	0.4	0.6	0.8	1	2	4	6	8	10
Object size (mm)	240 x 360	120 x 180	60 x 90	40 x 60	30 x 45	24 x 36	12 x 18	6 x 9	4 x 6	3 x 4.5	2.4 x 3.6

If you want to know intermediate values, or if you are interested in different film formats (see Chapter 2), you can easily calculate these by the following formulae:

$$1 \; \text{Magnification} = \frac{\text{Image size}}{\text{Object size}} \quad \text{or}$$

$$2 \; \text{Object size} = \frac{\text{Image size}}{\text{Magnification}}$$

There are various practical ways and means to determine magnification, which will be discussed in greater detail later. We will be constantly returning to the term magnification because it governs practically every technical aspect of close-up photography—depth of field, object size, extension factors, exposure correction, and so on.

Depth of field

In general photography we are accustomed to controlling depth of field by means of variation in (a) focused distance (b) *f*-stop used and (c) focal length of the lens.

In close-up photography our priorities are entirely different. Depth of field depends only on the magnification (and the *f*-stop used), and not on the focal length of the lens. So there is no advantage in changing the focal length of the lens in order to gain depth of field. For a given (or desired) magnification you always have the same depth.

The only way to adjust the depth of field is by changing the *f*-stop, and even here the possibilities are severely limited, as we shall shortly see. The relationship between magnification and depth of field is shown in the next table, which has been calculated for 35mm photography (circle of confusion (z) = 1/30 (0.03) mm).

1.2 Depth of field for magnifications from 0.1 to 10 x (mm)

Magnification	f-stop					
	5.6	8	11	16	22	32
(1:10) = 0.1 x	41	58	80	116	160	232
(1:9) = 0.111 x	33	48	65	95	131	190
(1:8) = 0.125 x	26.6	38	52	76	105	152
(1:7) = 0.149 x	20.7	29.6	41	59	81	118
(1:6) = 0.16 x	15.5	22.2	30.5	44	61	89
(1:5) = 0.2 x	11.1	15.8	21.8	32	44	63
(1:4) = 0.25 x	7.4	10.6	14.5	21.1	29	42
(1:3) = 0.333 x	4.4	6.3	8.7	12.7	17.4	25.3
(1:2) = 0.5 x	2.2	3.2	4.4	6.3	8.7	12.7
(1:1) = 1 x	0.74	1.06	1.45	2.11	2.9	4.22
(2:1) = 2 x	0.28	0.4	0.54	0.79	1.09	1.58
(3:1) = 3 x	0.16	0.23	0.32	0.47	0.65	0.94
(4:1) = 4 x	0.12	0.16	0.23	0.33	0.45	0.66
(5:1) = 5 x	0.09	0.13	0.17	0.25	0.35	0.51
(6:1) = 6 x	0.07	0.1	0.14	0.21	0.28	0.41
(8:1) = 8 x	0.05	0.07	0.1	0.15	0.2	0.3
(10:1) = 10 x	0.04	0.06	0.08	0.12	0.16	0.23

4 This portrait, taken at approximately 0.1 X magnification marks the borderline of close-up photography for the 35mm format: A head-only portrait covers an area of 25 X 35cm more or less exactly. This example however, has also been selectively enlarged.

5 This picture represents the middle of the close-up range. Here the limitations of the small depth of field already become very noticeable. Magn. 0.5 X, *f*/11, 1/125 sec, available light, 100mm macro lens, hand-held camera, windshield.

6 The same subject, but this time weak flash was used as a fill in. With this magnification (1 X) we enter the field of macro photography. (Other data as for illustration **5**, except exposure time, which was 1/60 sec.)

(Note that the relationship between magnification and depth of field is different for other film formats and image areas due to a different ratio between the circle of confusion and the image size. More about this in Chapter 11.)

Another difference concerning depth of field in general photography and in close-up work, though not vitally important, is worth mentioning here. In general photography depth of field, for practical purposes, is taken as extending from a position roughly one third in front of the plane of sharpest focus to two thirds beyond it. In the close-up range the differences are virtually indistinguishable and depth is treated as extending for an equal distance in front of, and beyond, the focused plane. The depth of field quoted for close range is therefore normally the *total* depth from the nearest to the furthest point of acceptably sharp focus.

Effective aperture

Unfortunately the depth of field values given in the preceding table cannot be used indiscriminately because your choice of *f*-stops is limited in two directions at once. A lens designed for general photography can be used in close-up work (on bellows etc.). However, you are forced to set relatively small *f*-stops in order to overcome the inevitable loss of lens performance due to its use

in this mode. On the other hand you cannot stop down as much as you would like because of the risk of deterioration of image quality due to diffraction.

You must know more about this if you want to go in for work at magnifications of greater than 1 x because in this range, together with camera movement, it is the most common cause of unsharp pictures. I will explain this in greater detail.

The *f*-stops which are engraved on the lens barrel represent the approximate ratio between the focal length of the lens when it is focused on infinity, and the diameter of the opening of the diaphragm (or pupil). This is complicated by the fact that the intensity of light reaching the film after passing through the lens, of whatever given size, reduces with the extension of the lens away from the infinity setting. Therefore, larger magnifications, which lead to greater extensions, result in an 'effective' aperture which is smaller than that actually indicated on the lens—which, by the way, is the reason why you have to increase the exposure time with longer extensions.

Another problem arises out of the fact that the edges of the diaphragm itself tend to diffract some of the light rays passing through the lens. These rays, as a result, behave in a disorderly way and cause loss of sharpness in the image—the more so, the smaller the *f*-stop.

In general photography, with the scale of image reproduced and the apertures used, the effects of diffraction are insignificant. In any case most lenses have a limit to the smallest apertures that can be set. which ensures that diffraction does not materially come into play. Only when these lenses are used on extension rings or bellows does the *effective* aperture become so small that your choice of *f*-stop may be limited to the larger apertures.

 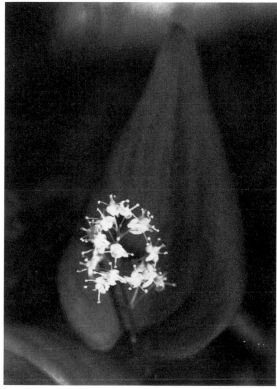

1.3 Part I: magnification range 0.1 x – 0.5 x

No limitation of *f*-stops

1.3 Part II: magnification range 0.5 x — 1 x

It is advisable to use *f*-stops not smaller than *f*/11 if you want the best possible lens performance. This applies even to special macro lenses. Most lenses give their best overall performance at about three stops down from maximum aperture.

7 and **8** This pair of pictures shows that a limited depth of field is not always a disadvantage. In my opinion, the composition of the first photograph is better, because the out-of-focus background simplifies and strengthens the composition. **7.** *f*/3.5, **8.** *f*/11, other data: automatic exposure, 100mm macro lens, available light, hand-held camera.

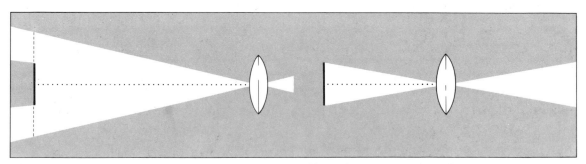

Fig 1 As the lens extension (the distance between the lens and the film) is increased, the light is spread over a greater area and therefore the amount falling on the film is reduced proportionally. The reduction is (approximately) inversely proportional to the square of the distance between lens and film.

1.3 Part III: magnification range 1 x − 30 x
Note: The precise values given in the table below apply to one individual lens. However, they serve as an approximate guide to the application of lenses in this magnification range.

Magnification	1 x	2 x	3 x	4 x	7 x	10 x	15 x	20 x	30 x
Optimum performance Generally*	11	5.6 to 8	5.6	4	2.8	2	—	—	—
usable	22	16	11	8	5.6	4	2.8	2	—
Limiting value	45	32	22	16	11	8	5.6	4	2.8

In some cases you might obtain better results by actually shooting at a lower magnification than you really want (in order to avoid the effects of diffraction and gain depth of field) and subsequently enlarge the negative image by a greater amount. Where image deterioration is due to other failings (oblique optical aberrations) you may find that loss of absolute sharpness is confined to the outer areas of the image only and the centre remains quite sharp. Such cases may still give acceptable results when the main subject is concentrated in the middle of the picture, as often happens when photographing small animals and the like.

Extension and exposure correction

So far, I have used the term 'extension' without explaining what it actually means—indeed it seems self-evident. But it is a colloquial term only, which is usually taken to mean the distance by which the lens is moved forward from its normal position on the camera in order to increase the separation between lens and film plane. As the amount by which the lens is moved has a direct bearing on magnification and exposure correction, some means of measuring must be found as a basis for calculation of the changed conditions. Such calculations for exposure correction are, of course, unnecessary where you are able to use a camera with through-the-lens (TTL) exposure metering, as this takes account automatically of any changes in exposure due to lens extension. But in other conditions, for example, using flash (if the TTL meter cannot read for flash exposures) or where no TTL metering is available and you do not wish to make a series of tests at different exposure settings, then some kind of calculation is necessary to determine the correct exposure.

For various reasons to do with modern lens construction it is usually impracticable to take measurements from optical points in the lens, such as from the centre or from the rear nodal point.

One way to work is to determine extension as a factor indicating the relationship between the distance from the rear flange of the lens (at the bayonet) to the lens mounting flange of the camera body, and the focal length of the lens. In order to calculate this extension factor, you must use the same units of measurement (ie. mm) for both of these values. The extension factor then is calculated by dividing the actual extension by the focal length, thus:

$$\text{Extension factor} = \frac{\text{distance from lens flange to camera flange}}{\text{focal length}}$$

(An example: extension tube 20mm is used with 50mm lens at infinity setting, so $^{20}/_{50}$mm $= 0.4$ (extension factor, EF). Taking E as the new exposure time to be calculated and e as the exposure time indicated without the extension, then the simple formula using the extension factor (EF)

$$E = e\,(1 + EF)$$

gives you the new exposure time.

If you wish to adjust exposure by changing the f-stop, you can find the new (effective) f-number (F) compared with the old (relative) f-number, using the extension factor (EF) with the formula as follows:

$$f = f\,(1 + EF)$$

The following table indicates the degree of exposure increase in nearest workable (rounded off) f-stops.

1.4 Exposure increase

Magnification	0.2	0.4	0.7	1	1.4	1.9	2.3	3.0	3.5	4
Extension factor	0.2	0.4	0.7	1	1.4	1.9	2.3	3.0	3.5	4
Correction— open aperture by f-stops	0.5	1	1.5	2	2.5	3.0	3.5	4.0	4.5	5

As you can easily see, the numerical value of the extension factor and for magnification are the same. So you could arrive at the necessary exposure correction by finding out magnification through actually measuring the difference between the subject and the image on the viewing screen.

9 With outdoor subjects and possible highly light-absorbing surroundings or distant background, flash exposures can be rather unpredictable. At medium close range and with a subject on the ground, this problem is minimised. Here, auto flash and TTL flash metering should be quite reliable.

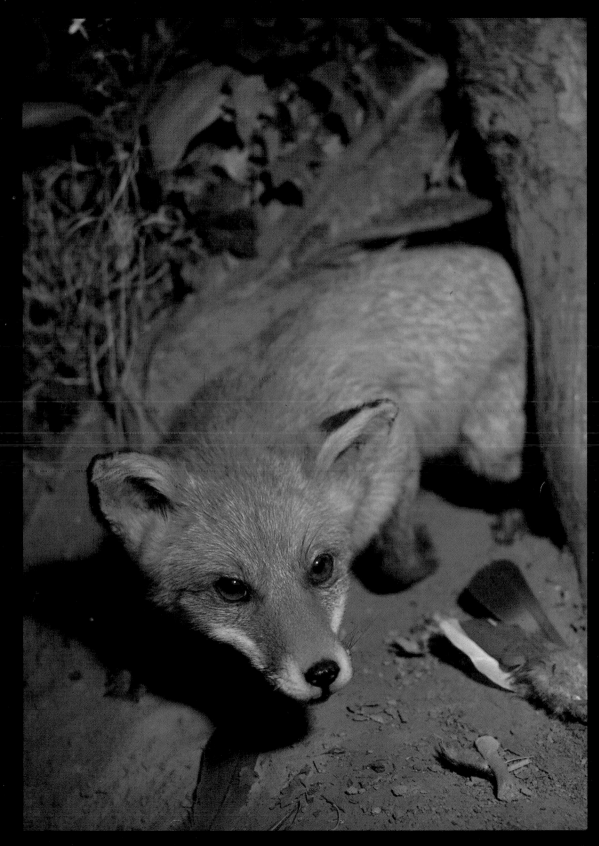

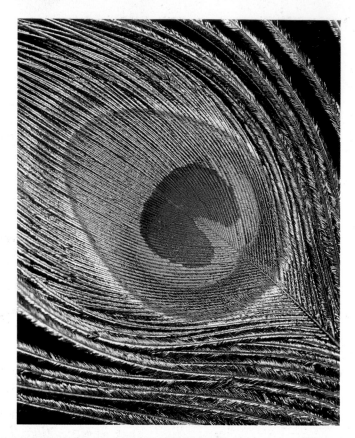

10 A half-way stage between documentary and creative close up photography, this peacock feather is a subject that lends itself to compositional possibilities without the need for techniques other than those required for a good clean documentary record. It may be simply a matter of seeing the potential in the subject and photographing it in a slightly different way that makes the difference between a record and an original picture. Original: 5 x 4cm, Magn, 1 x electronic flash spotlight.

11 This picture, which should be compared with the black-and-white version on page 22 shows clearly how the dimension of colour benefits particular subjects and situations in close-up work. Although in the monochrome version the subject is clearly differentiated from the surroundings, here the effect is increased.

2 CLOSE-UP EQUIPMENT

With equipment for general photography the question of choice can amount to quite a philosophy, with such factors as negative size and selection of interchangeable lenses being determined sometimes only by personal whim. In close-up photography, however, the choice of equipment is almost completely dictated by necessity. In purely technical terms, certain equipment can even be described as the best possible—as long as 'best' is defined as the most versatile; that is, the kind of equipment which allows you to solve the greatest number of close-up problems with the least possible difficulty.

But not even the best known pundits of photographic theory necessarily agree completely on some of the finer points, any of which may have a bearing on your choice of equipment. So I will go into theoretical questions only if I think that they cannot be avoided. At the same time, I would like to ask you not to wander off 'theory-gazing' because this will not help you in any way to take better close-up photographs. This is of course not only true for this chapter, or this book, but for the whole of photography.

Film format

Generally speaking, the smallest available negative format is the best choice for close-up photography, simply because the magnification necessary to depict an object of given size on the full negative format is reduced the smaller the negative size. An object of 24 x 24mm that can be photographed with a magnification of 1 x on 35mm film needs a (roughly) 2.5 x magnification with a 6 x 6cm format camera.

Because the problems of close-up photography, such as lack of depth of field, increase with the degree of magnification, the smaller format obviously has an advantage here. In addition, 6 x 6cm equipment is heavier, more cumbersome and much more expensive. Apart from this, many of the interesting and extremely helpful features found on 35mm cameras are not available in the medium format. Consequently, medium format cameras are, in general, more difficult to use for close-up work. That does not mean that you cannot take excellent close-up photographs with a camera of this type—especially as the larger negative has definite advantages when it comes to making enlarge-

ments of great size. This point, of course, applies even more to large format cameras which, curiously enough, have some additional points working in their favour.

We have seen in the first chapter that a severe limitation of photography at high magnification is that we are forced to avoid the use of small apertures, because of the risk of deterioration in image quality due to diffraction. A much smaller degree of enlargement is needed from a large film format in order to arrive at a desired picture size. (A 35mm negative must be enlarged approx. 7.5 x in order to obtain a print size of 18 x 24cm, whereas a 9 x 12 negative needs only a 2 x enlargement!) Therefore restrictions applying to the larger cameras, such as that using a 9 x 12cm format, are much less severe.

As far as our practical intentions go, the differences amount to the following. Although you need a magnification which is (roughly) 3.5 x greater than that for a 35mm negative, in order to fill the whole 9 x 12cm frame with a given object you can still obtain a greater depth of field because stopping down is not, in practice, limited.

Additionally, you can use lenses designed for 35mm photography to obtain even higher magnification, which leads to even better image quality due to their smaller circle of confusion—the patch, or disc of light that a lens produces in the film plane from a point in the subject.

(For the specialist—circle of confusion for 35mm photography lenses is 0.03mm, for medium formats it is 0.05mm, which means that the ratio between the image diagonal and the circle of confusion is at best 1.5 x greater than the required minimum in 35mm photography, while it is 3 x greater—and with lenses for 35mm photography on large format (eg. 4 x 5in) cameras even greater—than is necessary for standard resolution. That is why you have so much more leeway in stopping down when using the larger format!)

On the other hand, a large format camera is very slow in handling and normally can only be used with a tripod, so that its applications are restricted to stationary subjects. Nevertheless, measurement of continuous light and flash at the film plane is available for view cameras by means of a meter designed to read off the viewing screen. Additionally, you have the advantage of all the movements usually available with this kind

of instrument, although some of the latter are nowadays being offered for 35mm cameras as well (see comments on bellows, Chapter 6).

To conclude, the specialist may well find that a large format camera suits his requirements best if he goes in for stationary subject matter. Apart from this, the most obvious choice is the 35mm SLR camera.

Therefore, unless otherwise indicated, I will limit further discussion in this chapter to the various advantages of 35mm SLR cameras.

The 35mm system

If you do not, as yet, have a 35mm SLR camera, or if you are thinking about buying a special one for your close-up work, you should consider carefully the following points, because they can help you to avoid some costly mistakes:

1 TTL measurement: a few cameras have automatic exposure systems which do not work in the stopped-down mode and so cannot be used with the special equipment you will be using, such as bellows, special macro lenses, reversed lenses, etc. These cameras should be avoided.

2 TTL flash measurement: some of the more recent camera models offer this feature (with automatic adjustment of flash duration). For the close-up photographer this is one of the best developments of recent times. It does not answer the needs of every possible exposure situation, but it is an immense advantage in most. So this should be an important consideration when choosing a camera.

3 Cameras with aperture priority automatic exposure systems can be used, while those cameras which automatically select the aperture are unusable for close-up work if you cannot switch off the automatic system completely.

4 Cameras with interchangeable viewing screens are preferable because standard viewing screens can be very difficult to handle with high magnifications.

5 The viewfinder should, if possible, be interchangeable, or it should at least be possible to attach an angle viewfinder. (There is even a camera which offers both an eye-level and waist-level viewfinder at the same time.)

6 There is a practical advantage to a camera that will accept a power winder (or motor drive).

7 Although there is only one 35mm camera that allows it (medium format cameras mostly do), the availability of interchangeable film magazines would be quite advantageous, because exchanging camera bodies can be quite an awkward business with a variety of equipment combinations.

8 The camera system should include special close-up equipment like bellows, extension tubes, macro lenses and so on. However, all these items are also offered by independent manufacturers, so that this is a minor consideration, provided that the independent system can be fitted to your camera. Obviously a camera need not have all of these features in order to be useful for close-up work, but if you intend to purchase a camera you should look for them as they would constitute the optimum in versatility and ease of handling.

On the other hand, you don't have to despair if you own only a simple camera because you can probably do most things with your kind of camera as well—provided that you put in a bit more work and thought. We will discuss all the necessary equipment and techniques in the following chapters.

Choosing a film

Closely related to the problem of camera format is the question of software. If, for example, you often go in for very big enlargements, you will either have to use film with very fine grain, or a larger format than 35mm. Despite what I said in the preceding paragraphs it might then be better for you to use 6 x 6cm or even larger equipment. But this is a problem that cannot be solved in general terms.

Another question of more general interest is that of the different properties of colour and black and white films when used in close-up work.

There are, of course, ordinary aesthetic considerations or matters of personal preference in the choice. But close-up work adds some other factors.

Apart from when shooting flat subjects or copying, the extremely small depth of field becomes very noticeable and it is often impossible to show the whole subject, say an insect or a plant, with complete sharpness.

With black and white photography this causes two problems simultaneously; those parts of a picture which are wholly out of focus (and in close-up photography this may well be the

12 A typical example of a subject that lends itself to black-and-white photography treatment. It consists of only a few grey values in well defined areas, forming a bold composition. Magn. 0.7 X, available light (opposite), f/8, 1/250 sec, 50 mm macro lens.

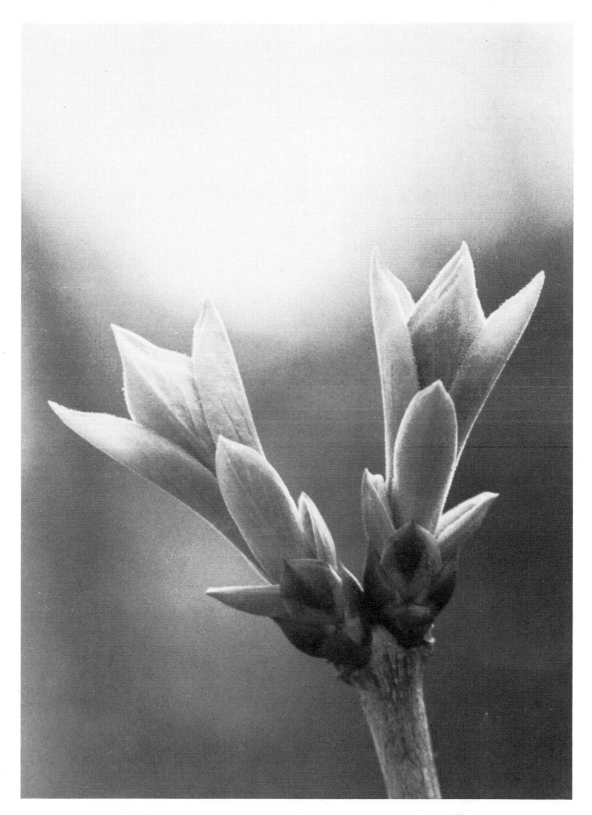

greater part of the picture) are rendered in an indefinable and indifferent grey which is, compositionally speaking, very difficult to handle. The second problem is that the viewer may have a problem in identifying parts of the subject which are out of focus and distinguishing them from the background.

In colour photography this is much simpler. Out of focus backgrounds often merge into a pleasing mixture of colour, which is much easier to incorporate in the composition. Additionally, colour enhances the recognisability of the subject because it provides additional information.

It is safe to conclude, therefore, that in contrast to general photography, colour is easier to handle in close-up work and often yields more pleasing results. On the other hand, black and white close-up photography offers a real challenge to the creative photographer and it is my private opinion that a really first-rate monochrome close-up photograph can be much more striking, if only because it is seen less often.

Be that as it may, colour film will probably be your first choice and, as I have explained above, you can't go far wrong with it.

Quite a different problem is posed by the choice of film speed. On the one hand, you would

13 Although the information in this monochrome picture is clear and fairly complete, the colour illustration (page 18) simply looks more pleasing due to the nicely contrasting colours of the subject. Magn. 0.5 X, *f*/16, 1/60 sec, 100 mm macro lens, flash (for both pictures), camera on monopod, wind shield.

14 The subject matter of the monochrome illustration is very difficult to recognize, because the grey values into which the various colours have been transposed are very close to one another. In cases of this kind colour photography is virtually essential; the picture looks more interesting and pleasing and the information content is enhanced. (Data as in **11** & **13**).

probably prefer to use a very fine grain material which, in consequence, would have a low film speed. On the other, lengthy exposure times might force you to use high speed film, which would limit its usefulness for big enlargements. So when a larger format is out of the question, stick to the following guidelines:

In strong daylight you can use low speed film (say 25 or 50 ASA) for magnifications up to 0.5 x without resorting to a tripod or to flash. Hand-held exposures with available light for magnifications of greater than 0.5 x should be made on high speed film, otherwise exposures will become too long. With flash you are obviously not bound by

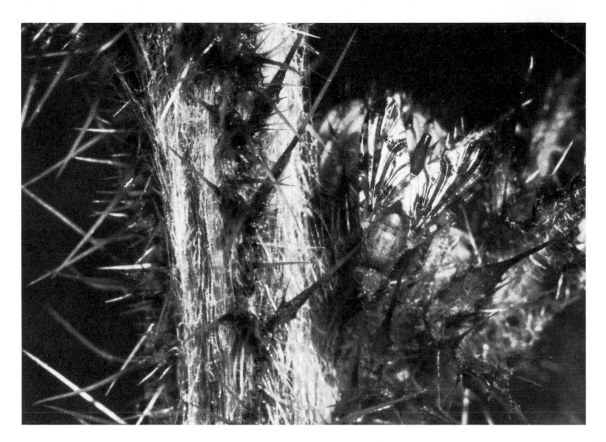

these limits, so you can choose film with very fine grain (and in colour photography with good saturation) without further consideration.

Cost of close-up photography

Leafing through this book, you might have gained the impression that close-up photography is a very costly undertaking. This could hardly be further from the truth.

Compared with general work, close-up photography can be very cheap, even if you take into account versatile equipment of the very best quality.

You will of course need a camera body. But you probably already have one and are using it for other purposes. The next consideration is special equipment for the range of magnifications from 0.1 x to 1 x. The cheapest way to work here would be to use extension tubes together with lenses designed for general photography which, again, you probably have. A set of extension tubes will not cost more than two or three good quality filters of the screw-in type—perhaps a bit more in the case of automatic extension tubes. A special macro lens would be more convenient. But this is likely to cost about as much, say, as a telephoto lens of 300mm focal length.

For magnifications of between 1 x and 10 x you either need a bellows unit (together with a focusing rail) which is less expensive than, for example, a macro lens and can be used with lenses for general photography (in the reversed mode). Or you need a bellows unit together with special lenses designed for high magnifications (of the Luminar or Photar type). The latter are much less expensive than a normal macro lens. Some manufacturers supply a helical focus unit for use with macro lenses, a kind of extension tube of variable length which represents a compact substitute for bellows but with a more restricted operating range.

Apart from things which will already be in your bag for use in general photography (ie. tripod, cable release, flash etc.) you need nothing else to cover the whole range of close-up photography from 0.1 x to 10 x magnification.

You can, of course, spend much more money on highly sophisticated and specialised equipment which will allow you to work in certain fields with greater ease and comfort. But basically, all you really must have is what I have described above—and that will cost you less than a more or less complete outfit for general photography.

3 CLOSE-UP PHOTOGRAPHY WITHOUT SPECIAL EQUIPMENT

If we consider that close-up photography starts at a magnification of 0.1 x, the result with a 35mm camera is an object size of 24 x 36cm which could, for example, be used for a head-only portrait. This range is covered by almost all lenses intended for general photography. But many have a still smaller minimum focus setting, so that with one of these, you can enter the field of close-up photography without any special equipment whatever.

Obviously, the minimum focus distance, and with it the available magnification, differs between lenses. But the following table shows an average sample which should be at least approximately valid for your equipment.

The first column shows the focal length of the lens, the second, maximum magnification, the third, the equivalent object size and the fourth column, the focusing distance.

3.1 Focus distance and magnification

Lens focal length (mm)	Magnification	Object size (cm)	Focusing distance	Magn. with extender	Object size with extender (cm)
17	0.11 x	21.9 x 32.8	0.25	—	—
21	0.17 x	14.2 x 21.2	0.25	—	—
24	0.12 x	20 x 30	0.3	—	—
28	0.14 x	17.1 x 25.7	0.3	—	—
35	0.19 x	12.6 x 18.9	0.3	—	—
50	0.13 x	18.4 x 27.7	0.5	0.26	9.2 x 13.8
100	0.13 x	18.4 x 27.7	1.0	0.26	9.2 x 13.8
135	0.11 x	21.9 x 32.8	1.5	0.22	10.9 x 16.4
200	0.1 x	24 x 36	2.5	0.2	12 x 18
800	0.12 x	20 x 30	8	0.24	10 x 15
40-80	0.17 x	14.2 x 21.2	0.37	0.34††	7.1 x 10.6
80-200	0.13 x	18.4 x 27.7	1.8	0.26††	9.2 x 13.8
100-500	0.28 x	9.1 x 13.6	2.5	0.66††	3.6 x 5.5
100-500†	0.48 x	5 x 7.5	1.6	0.96††	2.5 x 3.75

(† = with auxiliary lens designed for this equipment)
(†† = check manufacturer's recommendations)

Extender (converter)

The last two columns of this table need some additional explanation. Many people nowadays own a tele converter (or extender) of good optical quality. An auxiliary lens of this kind serves to increase the effective focal length of a lens without affecting the focusing range in any way. So, by adding a 2 x converter, for example, the magnification possible with any lens can be doubled.

Most of these extenders (especially those of very high optical quality) have been corrected for use with certain groups of lenses. A typical example would be an extender for lenses of 85-300mm in focal length. These specifications have not been taken into account in the table, because they vary from one make to another.

Apart from this, the usual precautions for the use of extenders should be taken. That is, in addition to compensating for the two whole f-stops which you lose anyway with a 2 x extender, you should also stop down according to the manufacturer's instructions to ensure good quality. Additionally, you must remember that doubling the focal length of your lens greatly increases the risk of getting blurred pictures, because the effect of camera movement is doubled as well. Moreover, doubling of magnification results in an approximate halving of depth of field.

Generally speaking, the use of extenders should not be scorned, because there are some definite advantages. Extenders of a good optical standard will not lead to a noticeable deterioration in image quality if properly used. Often, longer focal length lenses are rather restricted by how close they can focus, so doubling the focal length of a lens, for example converting a 100mm lens into a 200mm one, could actually be better for close-up photography than using a lens of the appropriate 200mm focal length. The unchanged minimum focusing distance of the combined lens and extender may allow much greater magnification than is possible with the minimum focus setting provided on the 200mm lens.

Using wide-angle lenses for close-up

If you have the choice between normal wide-angle lenses and those with floating elements, which are offered for many cameras, you should always choose the latter, because the floating element construction serves especially to improve the lens performance at short range by offsetting the effects of spherical aberration. But, despite advice to the contrary, most wide-angle lenses of ordinary construction perform satisfactorily for close-up work provided that they are well stopped down, that is, if you do not insist on using them for reproduction purposes. Flat objects like paintings or printed matter tend to show the slightest flaw of image quality, whereas the same flaw would probably not be noticeable with three-dimensional subjects, or would be attributable to the limited depth of field.

When studying the table, which shows the maximum magnification for a variety of lenses, you might be tempted to think that it is irrelevant whether you use, for example, a 17mm or a 135mm lens, both of which offer the same potential magnification of 0.11 x. This could be argued, because the depth of field for both lenses would be the same for an image of the same size.

Indeed, the depth of field tables for lenses of these focal lengths indicate approximately 2cm in both cases (at f/2.8).

Nevertheless, there are arguments for and against the use of either lens. Firstly, the working distance (ie. the distance between the front element of your lens and the subject) decreases or increases with the focal length of your lens. A look at the table will show you that the focusing distance of the 17mm lens is 0.25m, while it is 6 x greater (1.5m) for the same magnification if you use the 135mm lens.

This seems to speak clearly in favour of the longer lens. But there are cases where wide-angle lenses may be better. Although depth of field is always the same irrespective of focal length, with a change in shooting distance the perspective impression (indeed the *actual* perspective) of your picture changes.

A wide-angle lens would show much more of the background of your subject matter than a long focal length lens—something which would be quite important if, for example, you want to give an impression of the habitat of a living subject.

Using standard and telephoto lenses

With lenses of longer focal length conditions are reversed for these more creative aspects of picture-making.

In contrast to the all-encompassing views possible with wide-angle lenses you obtain more restricted, in some respects more intimate, renderings of your subject matter. Of course, what you prefer depends on your ideas concerning the realisation of your photograph—as well as technical considerations.

The longer focal length lens has two advantages. First, the greater working distance made possible by such a lens allows you to avoid problems with the lighting. In some situations at close range you can, for example, obscure at least part of your subject matter with your own shadow—certainly if you have to come as close to it as 0.25m. But this need not happen with the working distance of 1.5m or more available to you with a lens of greater focal length.

The second advantage is that wild animals being very shy, you are usually prevented from getting very close to them. Here, obviously, the longest practical focal length would be best. But with this you also have the disadvantage mentioned before. As you know, the danger of blurring pictures due to camera movement increases with the focal length of the lens. Unfortunately, this danger increases even further with magnification, so that hand-held cameras with long focal length lenses at a very short range require extreme care, which simply means using a very short exposure time—and that too could be a problem, as we shall see later.

Another practical consideration is that adjusting the focus on lenses of very long focal length is sometimes inconvenient and slow because of the relatively lengthy travel on the focusing ring. This can be a major disadvantage when 'hunting' small animals—which can usually move more quickly than you anyway. Trying to hold the camera steady while focusing such lenses can also be a problem. If you are lucky enough to possess a follow-focus lens these difficulties are overcome.

Zoom lenses and others

Your equipment for general photography may include a zoom lens. It is difficult to generalise about a whole class of lenses, but many zoom lenses leave much to be desired in the way of optical quality. Depending on the type of close-up subject you are taking, this could be a problem. The shortcomings of such lenses, where they are present to any degree, include a tendency to give a poorer standard of definition in the image generally than a 'prime lens', especially towards the edges of the pictures at wide apertures, some unevenness of illumination, and distortion.

Although the best performance of a particular lens might be at one end or another of its zoom range, typically such lenses give the best optical quality at medium focal length settings and apertures. Here, too, distortion is at a minimum. The usefulness of any but the highest quality zoom lens in close-up work depends largely on the situation in which it is used.

If, with a particular lens, the desired standard of sharpness is confined to the central field, then this lens may still be suitable for close-up work with subjects concentrated mainly in that area, such as small animals in their habitat. Critical definition in the surroundings would be unimportant.

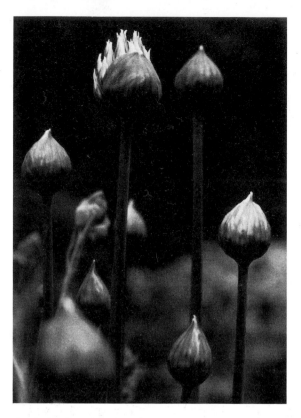

15 Standard lenses in close-up: the minimum focus range of many modern lenses permits 'group' composition in close-up, such as these buds, without the need for special lenses or attachments. At such focus ranges there is no difficulty in obtaining sufficiently diffused background or foreground features to distinguish subject from surroundings.

16 Taken at a focused range of 0.25m with a 17mm wide angle lens, this picture illustrates the use of 'non-specialist' lenses in close-up photography. The foam in the foreground is shown at a magnification of approx. 0.1 X, while the sweeping perspective of the 17mm lens used here allows you to localize and identify the subject matter. Taken with a 100mm lens, it might have been foam in a bathtub; f/16, 1/60 sec available light, hand-held camera with angle viewfinder.)

17 Standard non-specialist lenses are quite adequate for 'tapestry' close-up pictures, where the subject matter, seen flat-on, is arranged in a pattern within the picture area. This is the most technically undemanding type of close-up picture of all — the limited depth of field required, the lack of need for colour (in most cases), the stationary subject matter, the time available to compose the picture and the suitability of most light sources, including quite poor available light. The essence of the picture is in the observation and composition of the subject, perhaps helped by supportive darkroom technique to control tonal values.

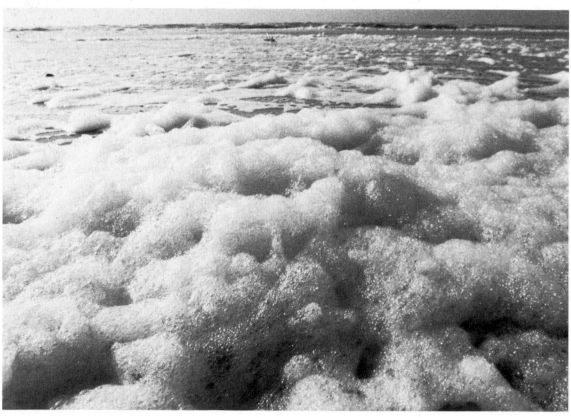

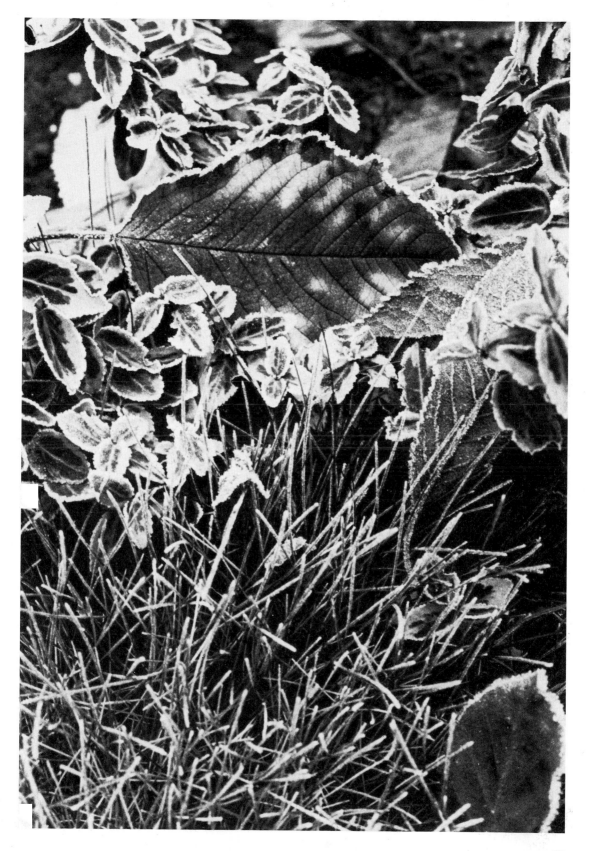

On the other hand, this lens would not be suitable for flat copy close-up work, for example, or other subjects with no depth or subjects having an even pattern across the field which would clearly show the shortcomings of the lens.

A zoom lens with a tendency to linear distortion, where straight lines in the subject are bent outwards (barrel) or inwards (pincushion) would be unsuitable for any subject having straight edges or taking a linear form. But this lens would be suitable for work with other subjects having no such straight edges, or seen against plain or irregular backgrounds. Distortion in zoom lenses usually varies with the focal length setting. At a particular focal length setting it will be least in evidence or eliminated altogether. This can be checked by test shots at various settings against a regular grid or straight lines positioned at the edges of the field.

Macro zoom lenses are designed to include focusing in the so-called macro range. Although they do not usually fulfil the promise of their name (you would expect a true 'macro' range to extend to life size magnification at least!) they do allow

18 If you cannot get close enough to your subject, long telephoto lenses come in handy. This photograph was taken with 100-500mm zoom lens with special auxiliary close-up lens. The magnification here is 0.8 X. 100-500mm lens, f/22, 1/30 sec, camera on tripod, angle viewfinder.

19 Although in close-up work the depth of field remains constant, irrespective of the focal length of the lens, the perspective impression can be vastly different. This photograph was taken with a 50mm wide-angle lens on a 6 x 7cm camera (a wide-angle lens for that format). The background, although entirely out of focus, forms an important part of the composition. Magn. 0.5 X (6 x 7cm format), f/16, 1/30 sec, available light, tripod.

20 For comparison look at this picture taken with a standard lens (90mm on a 6 x 7cm camera). It shows the perspective effect placed nicely between the two extremes. Magn. 0.5 X, (6 x 7cm format), f/22, 1/15 sec, camera on miniature tripod. The 6 x 7 camera used here has a built-in bellows unit.

21 In contrast to Ill. **19**, this photograph was taken with a 100mm lens (35mm camera). Note the entirely different rendering of the background. Due to the smaller angle of view only a small part of the background is visible. Magn. 0.,5 X (compare this with the same magnification for a 6 x 7cm camera in the preceeding picture!), f/16, 1/125 sec, against the (available) light, hand-held camera, windshield.

you to enter well into the close-up range. This is made possible in different ways. Some manufacturers offer extension tubes, others do it with extenders or supplementary lenses and still others have a built-in macro-mode. Again it is, of course, impossible to pass judgement on all such lenses as there will always be good and bad ones amongst them. It is likely, however, that a lens which does not perform very well in its normal range will become even worse when used for close-up. Macro lenses, as such, are discussed in detail on page 50.

4 AUXILIARY CLOSE-UP LENSES

The first special equipment for close-up photography that many photographers acquire is a supplementary close-up lens—and with that, they have done far less wrong than some people might think.

The supplementary close-up lens can be attached to the filter thread of most lenses. It works by reducing the effective focal length of the camera lens, thus allowing a shorter focusing distance and so, greater magnification.

A particular advantage of this lens is that it does not affect exposure and the masked apertures on the camera lens therefore still apply. On the other hand, such a radical change of what amounts to the optical construction of the total lens system can lead to serious losses in image quality (which is why the use of supplementary close-up lenses is often frowned upon). Curiously enough, this is not necessarily true. Although it is quite correct that a close-up lens does impair image quality, so, with some lenses, can the use of an extension tube because it, too, introduces an atypical condition into the working of the lens. In fact, there are cases where the use of a supplementary close-up lens may yield the best possible image quality.

Meniscus and achromatic

First, you must choose the right kind of lens. Basically, there are two kinds, the simple 'meniscus' lens and the achromatic, multicoated lens-system type (usually consisting of two cemented elements).

The latter type are far preferable to the simple supplementary lens if you wish to minimise loss of image quality. Simple lenses can only be used with the camera lens well stopped down. Achromatic supplementary close-up lenses are offered by a few independent manufacturers and as part of some camera systems. They are much more expensive than the simple type but should be your first choice, even if you have to hunt around for them.

Magnification with supplementary lenses

The magnification which is made possible by moving closer to the subject with a supplementary close-up (positive, marked +) lens depends on its focal length. However, such a lens is not usually categorised by its focal length but by its strength in diopters (D), calculated by dividing 1000 by the focal length in mm. The relationship between these data is: a lens with a focal length of 1000 mm is +1 diopter (+1D), one of 500 mm is +2 diopters (+2D), one of 250 mm is +4 diopters (+4D), and so on. (ie. $D = 1000/f$ where f is the focal length in mm). On the lens itself the focal length may be marked as $f = 1m$, $f = 0.5m$, etc.

The manufacturers usually provide a data sheet, tables for focused distance, object size magnification and so on. I think it suffices to show here some key data which may help you to decide which kind of lens to buy. The following table therefore lists only a few typical lenses, stating their magnification without supplementary lenses and with them. (It should be noted that achromatic close-up lenses may not be quoted in round numbers like +2, +4, +8 diopters, but sport such focal lengths as 263 or 1085mm!) This table refers to lenses which do exist and are quite common.

4.1 Magnification with supplementary lenses

Lens focal length (mm)	50	85	100	135	200
Magnification	0.13x	0.1x	0.13x	0.11x	0.1x
Magn. for lens plus	—	0.08x	0.1x	0.13x	0.19x
suppl. lens +0.95D	—	0.18x	0.22x	0.25x	0.32x
Ditto plus suppl.	0.11x	0.17x	0.2x	0.27x	—
lens +2D	0.23x	0.28x	0.33x	0.41x	—
Ditto plus suppl.	0.19x	—	—	—	—
lens +3.8D	0.33x	—	—	—	—
Combined suppl.	0.3x	—	—	—	—
lenses +2+3.8D	0.43x	—	—	—	—

Guidelines for use

This is a very cautious table, stating only those combinations where no loss of image quality will be noticeable with apertures of f/5.6 or smaller. Other combinations are of course possible. General rules for using these are as follows:

1 If using more than one supplementary lens, you should always attach the stronger one (the one with the shorter focal length or larger diopter number) into the camera first and then add the other. Avoid using more than two lenses.

2 While almost all zoom lenses are unsuitable for use with extension tubes or bellows because of a substantial loss of image quality, it is safe (or at least safer) to use them with close-up lenses.

3 Supplementary lenses should not be used with wide-angle lenses that have floating element

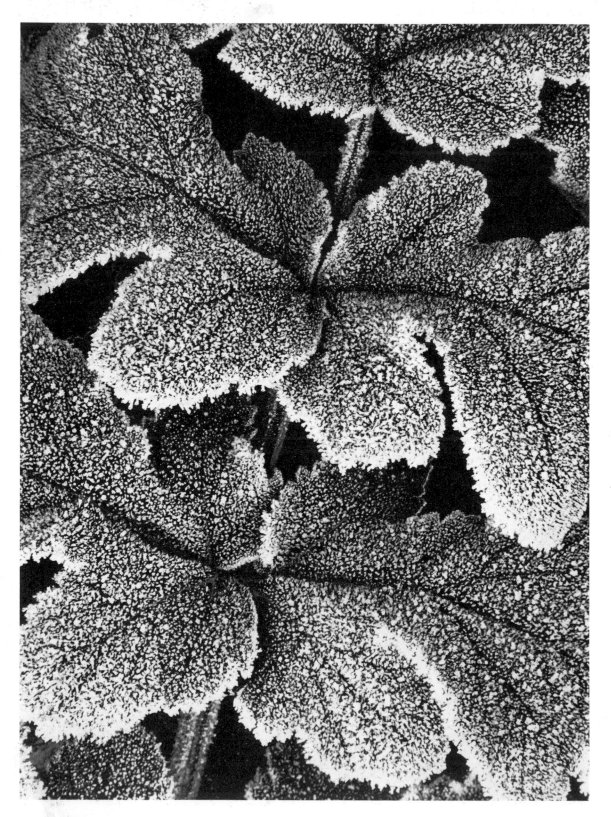

22 Frosted leaves. The scale and quality of reproduction required for such a subject is well within the capability of a single or, perhaps, two supplementary lens attachments used with a standard camera lens. They offer the advantages of simplicity by not interfering with exposure or its means of control and, under practical conditions with this type of subject, often gives a better result than more sophisticated means.

23 In indoor conditions with filtered lighting of low power, simple means are often the best. The negative aspects of supplementary lenses are either minimised or irrelevant. Critical definition was not required for this cave-like pepper where the shapes and the lighting effect were the main interest — indeed variously-sharp rendered surfaces can even distract from such a simple theme as this.

24 An achromatic close-up lens is capable of more precise definition. Here, the picture largely depends on the surfaces of the subject where shapes and textures are drawn out by the oblique coloured light. Such features benefit from exact representation in a picture.

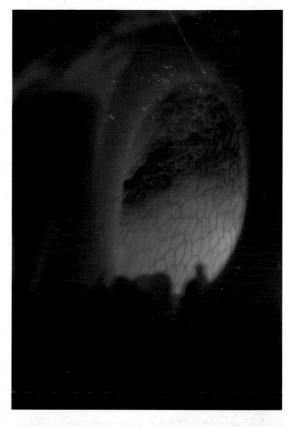

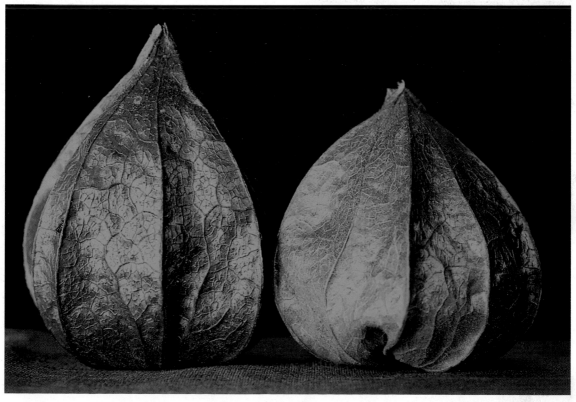

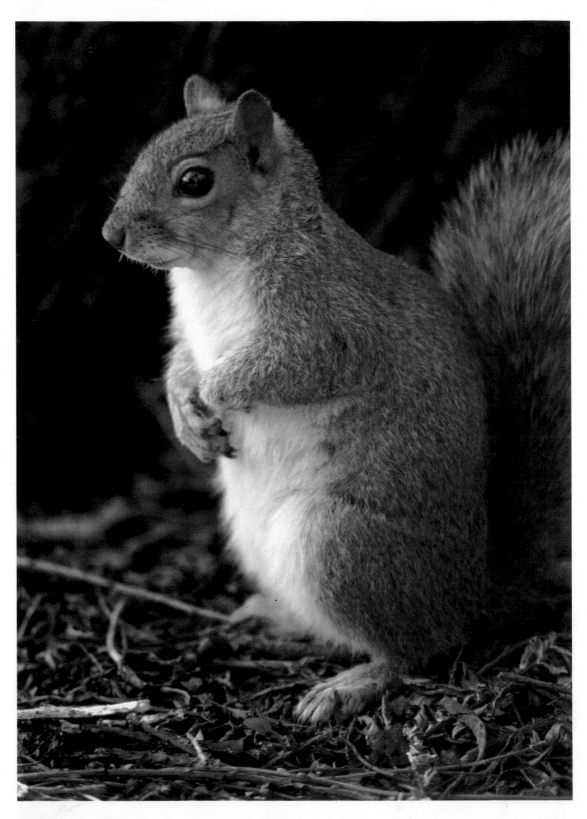

focusing systems.

4 Good achromatic supplementary close-up lenses can, indeed, even improve the close-up performance of lenses in the 50mm to 135mm focal length group if matched to the characteristics of the prime lens (eg. Leitz Elpro). Therefore you should always use an achromatic supplementary close-up lens. Of the two ways of getting to the desired magnification it is better here to use, say, a 1 diopter close-up lens in addition to bellows than to try to gain the entire magnification by bellows extension alone. Although being the best compromise this, however, is still inferior to a proper close-up or macro lens. (Although I doubt that you would be able to see the difference on your slides or negatives!)

With really close-up work, however, much depends on the individual lens design and shooting conditions, your expectations, the subject and other variables. The surest way to determine the suitability of supplementary + lens combinations is to do a test beforehand under representative working conditions (aperture, focused range, subject and so on).

To summarise, supplementary achromatic close-up lenses are relatively cheap (they will probably cost the equivalent of one or two first rate screw-in filters), light in weight and small, and they do not require exposure compensation. If selected with care and used properly, they do not visibly impair image quality. On the contrary; if you want to use tube or bellows extensions for greater magnifications, they can even improve image quality.

Therefore these lenses can well serve as a starting point for your close-up equipment and they will remain a good investment, even if you turn later to more sophisticated methods.

25 An animal as (relatively) tame as a squirrel in a public park is well within the compass of a photographer working only with a single close-up lens attachment. The enticement provided by some judiciously placed food, and a pre-focused lens, should be sufficient preparation to work successfully from a crouched position. It is very easy, however, to block the light or cast a shadow across the subject when working with a live subject and the camera constantly at the eye — so keep a watch out for this.

5 TUBES AND RETRO-MOUNTED LENSES

Extension tubes and bellows both serve to extend the lens-to-film distance and, with that, the magnification. Each has its own advantages and disadvantages and optimum applications.

Extension tubes are cheap, small, light in weight and easy to handle—although they have a few drawbacks as well.

Apart from special extension tubes which belong to certain lenses (see macro lenses, page 50), these tubes (or rings as they are also called) are usually sold in sets of three to five tubes of varying lengths. The tubes can be used separately or in different combinations, so that you have a wide range of extensions at your disposal.

Auto or manual

With many cameras you have a choice between two basic types of tube; you can buy sets of extension tubes which link all automatic functions of the camera and lens (especially full-aperture exposure metering and automatic stopping down) while other models are of a simpler type which require you to operate these functions manually.

Nevertheless, these simpler models have a definite advantage due to their light weight and small size. And if you intend to use them mainly with lenses in the reversed (retro) position (see below) or with special lenses or other devices which do not have automatic features anyway, then you have lost nothing by using these less expensive tubes.

On the other hand, automatic extension tube sets have a significant advantage when you want to use them, for example, for pursuing active natural history subjects, where the automatic stopping down and meter coupling may save valuable time. Here, trying to focus with the lens stopped down would be very awkward, because the image in the finder would be quite dark (you lose light not only because of the necessarily small aperture, or large f-number, but also because of the extension!)

Length and magnification

Although the lengths of extension tubes vary according to the ideas of each manufacturer, commonly the total length of a complete set falls within the 50mm-70mm range. The following examples are based on a typical unit consisting of three tubes with an overall length of 63mm. The table gives you an idea of the maximum magnifications possible with this set and lenses of different focal lengths.

5.1 Lenses and extension tubes: maximum magnification. Data for extension tube set of 63mm total length

Lens	Magnification	Distance to object
24mm (retro)†	4.5 x	41mm
28mm (retro)	4.1 x	44mm
35mm (retro)	3.2 x	48mm
50mm (normal)	1.2 x	54mm
50mm (retro)	1.9 x	65mm
85mm (normal)	0.67 x	173mm
135mm (normal)	0.42 x	440mm
200mm (normal)	0.28 x	1020mm

(† = for an explanation of retro- and normal position see below) All values given in this table are for the combination named with lenses at the infinity setting.

You can easily see that the combination of various normal lenses with extension tubes offers a wide variety of magnifications, especially so, because, alternatively, you can use the focusing range of the lens itself and, of course, different combinations of tubes. If your entire close-up equipment should, for example, consist only of a set of extension tubes (as described above) and a simple standard lens of 50mm focal length, you can cover the range of magnification from 0.1 x up to almost 2 x (twice life size) continuously!

Applications

You might still wonder whether you wouldn't be better off with a bellows unit (discussed in the next chapter), which is said to be more versatile. But, in my opinion, the advantages and disadvantages of both types of equipment speak for different applications. I have listed some of the main points below:

1 Small magnifications: single extension tubes allow extensions starting from 6-7mm (depending on the model) while the minimum extension of bellows is much greater.

2 Hand-held camera: due to lighter weight and smaller size, extension tubes have the advantage of convenient handling.

3 Automatic mode: there are not many bellows which allow you to use all automatic functions of the camera without some compromise arrangements such as a double cable release, while with extension tubes, this facility is available for almost

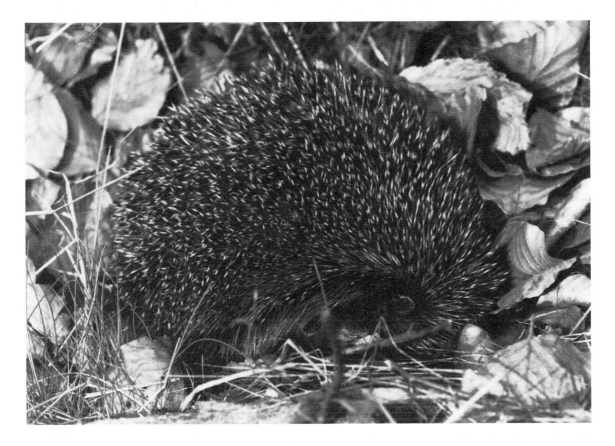

all cameras.

4 Continuous range of magnifications: here the bellows units have the advantage because they can be extended continuously and conveniently, while changing the magnification with extension tubes may require some fiddling around and may even leave gaps in the range of available magnifications.

5 High magnifications: with bellows the maximum extension is much greater than with extension tubes, so the same lens can be used for much higher magnifications.

Apart from the points mentioned here, both kinds of equipment afford the possibility of adapting out-of-the-way items (even of the home-grown variety) for use with your camera. This will be discussed later.

Using lenses in reversed position

I have already mentioned in passing the use of lenses in the reversed position (retro position). This can have special advantages.

When working in general photography, the greater distance is that between the object to be

26 This hedgehog was taken with a 200mm lens and an extension tube. Despite the considerable focusing distance, much greater than 2m, the animal had noticed my approach. Magn. 0.13 X, f/8, 1/60 sec, hand-held camera, available light.

photographed and the lens, while the distance between the lens and the film is much smaller. Normal camera lenses are designed for use in these conditions. But with magnifications of greater than life size, this relationship is reversed. The object-lens distance becomes smaller, while the lens-to-camera distance grows larger. In this situation, the lens is less efficient optically. But if the lens is now turned back to front, with the rear element facing the subject, the original relationship of relative distances is restored and, with the majority of lenses, the performance is likely to be improved. The absolute gain in quality varies with the shooting distance as well as the individual lens in use. You could test your lenses in the reversed mode beforehand, at various magnifications and aperture settings.

But using a lens in the retro position does not only improve picture quality, it has other

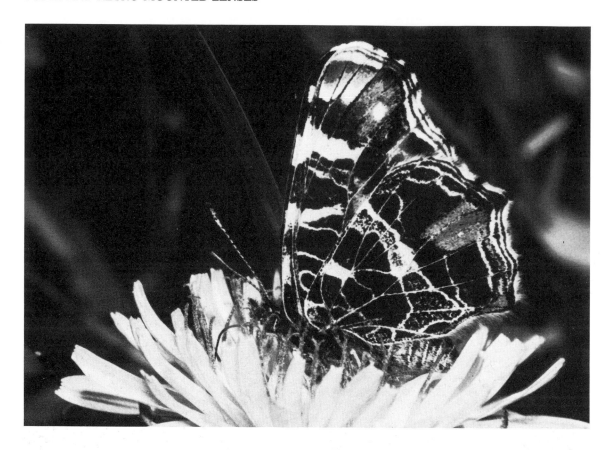

advantages as well:

1 While image quality may be only marginally better with magnifications of slightly more than 1 x, it is sure to improve at greater magnifications, simply because the increasing distance between lens and film more nearly approaches the conditions for which the lens was originally formulated.

2 With all lenses used in the normal position the lens-to-object distance diminishes with increasing magnifications.

A point is then reached where the lens is so close that the subject may be obscured by the shadow of the lens itself. In this position the lens may even make it impossible to light the subject properly. With lenses in the retro position this problem is minimised due to the particular (retrofocus) formulation of lenses for SLR cameras. A retrofocus lens is one in which the image is brought to a focus in a plane further behind the rear element than would be normal, in order to allow space for the reflex mirror to be accommodated between lens and film. Such lenses are likely to have a focal length which is actually less

27 Normally, I would have used a 100mm macro lens for this kind of subject, but having set up my equipment for an entirely different purpose, I shot this butterfly with a 50mm lens on my bellows unit. 0.5 X magnification, *f*/16, 1/60 sec, flash, hand-held camera. (A double cable release to preserve the stopping down function, was fixed with adhesive tape to the extension bracket of the flash-unit.

28 When a subject is photographed at ground level the background will, almost inevitably, be largely sky. This can mislead the automatic meter, so manual settings are advisable, if not essential. For such situations, there is little advantage to be gained from auto tubes, bellows or helical focusing units — manual accessories work just as well.

than the distance from the back of the lens to the film. As a consequence, when the lens is turned round there is a minimum distance between lens and object (usually in the range of 35-45mm, depending on the make of camera) which will not be shortened, irrespective of the magnification used.

This characteristic is particularly useful when using wide-angle lenses up to 35mm in focal length, because here the magnification that can

be achieved by the use of bellows or extension tubes could, indeed, result in shorter lens-to-subject distances than the above-mentioned, if the lens were not used in the reversed mode.

The same peculiarities of lens formulation which are responsible for the effect described above lead to the welcome fact that you can obtain the same magnification with a smaller extension! This is a very interesting possibility, because on the one hand it allows you to achieve greater magnifications with your equipment, while on the other, you can shorten the extension for any given magnification greater than life size

by reversing the lens, thus reducing the necessary increase in exposure. This applies to lenses of up to approximately 50mm in focal length—all those with retrofocus construction.

The lens is mounted in the retro position with the aid of a special reversing ring, available from most manufacturers of system cameras, independent lenses, or close-up equipment.

For some lenses, which cannot be used in the retro position due to technical problems, the manufacturers usually offer special bellows units, which make this possible nevertheless.

6 BELLOWS, RAILS AND FOCUSING CLOSE-UP

Although we have already seen in the preceding chapter that extension tubes are preferable for certain applications, it is nevertheless true that the bellows unit is the most versatile single piece of equipment for close-up photography.

Depending on its make, it usually furnishes continuous extensions in the range of 3 to 18cm, thus providing you with a photographing range extending from infinity to magnifications of up to 30 x (depending on the lenses used).

A bellows unit consists of a front and rear standard, the bellows itself and the optical bench along which one or both of the standards can be moved. The rear standard attaches to the lens mount of the camera and the front standard carries the lens. The separation between these two standards, and thus the lens and camera, is continuously adjustable, so providing the means of varying magnifications. When choosing a bellows unit you should look especially for two points: mechanical rigidity and ease of movement. Many bellows units that I have seen fall short of the manufacturer's promises in one or other or even both these respects. However, you can safely assume that practically all bellows units from well-known manufacturers will work quite satisfactorily with moderate magnifications—let's say up to 2 x or 3 x.

The trouble starts with higher magnifications. Quite frequently, for example, the standard of a bellows unit will shift slightly (perhaps a fraction of a millimetre) when unclamped and will return to its original position when clamped again! If this happens, then focusing at high magnifications either becomes impossible or must be done with a bit of trickery. Although the manufacturer's advice is to unclamp the rack and pinion or friction drive of the bellows standards before turning the focusing knob, you may well find that you must clamp it slightly while still adjusting the focus, alternately juggling with each control until the image is sharp. This is a bit like driving a car with the brakes half on and may even lead to the equipment wearing out prematurely, but it is the only way to overcome this problem.

Another common difficulty with the rack and pinion or the friction drive of the standards is that they often do not move smoothly enough for continuous focusing with high magnifications. Even if the whole unit is mounted on a focusing rail (see below), that might also suffer from the same problem. Unfortunately there is no way round this difficulty, so your equipment may restrict your work to lesser degrees of magnification where the margins of error are less critical.

However, to be fair to the manufacturers, this kind of equipment is not meant for extreme magnifications, although this should be more clearly stated in the advertising. Moreover, the mechanical problems involved in the construction of high-magnification equipment are quite considerable, so some compromise has to be sought which will still result in a relatively small, lightweight and financially affordable unit.

I mention these points only because on the one hand you should not expect the impossible, while on the other you should still exercise great care in choosing your bellows unit.

Now to take a closer look at this kind of equipment.

The bellows unit

In its simplest form, the bellows unit has a fixed rear standard and a front standard which can be moved back and forth for focusing. Although these units do, of course, work, it is much more advantageous if both standards can be moved. One of the reasons for this is that the projecting end of the rail which supports these standards or 'optical bench' can, in some situations, protrude further than the distance between the lens and the subject itself allows, and so interfere with your subject. Lenses of very short focal length, which have high magnifications even with short extensions, are especially prone to this. If, however, both standards are movable, you can then simply slide the front standard to the front end of your rail and focus with the rear standard.

In addition to the adjustability of both standards some bellows allow you to tilt the front standard, while one model (Hama bellows) even offers all the swings, tilts and movements which are normally associated with view cameras.

Although it is quite nice to have this scope, it should not be overrated, because I think that its use is restricted to the very specialised field of small-scale still-life, or table-top work. For general use in close-up photography it should be sufficient to have a bellows which allows focusing with both standards.

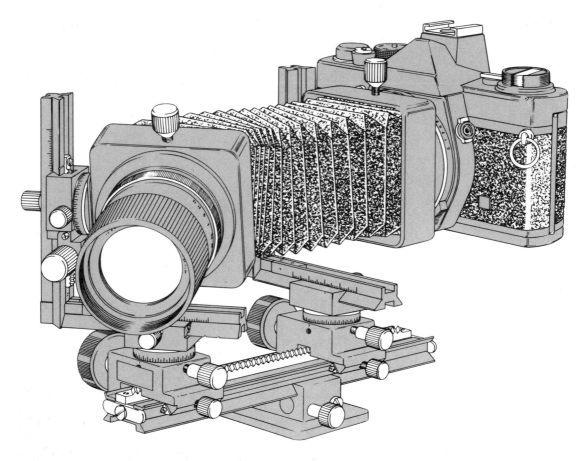

But what a bellows unit must have is a focusing rail (either built in or as an accessory). This is distinct from the rail or optical bench holding the standard and is usually mounted immediately beneath. The focusing rail provides the link between the tripod or copying stand (or camera support in general) and the camera/bellows unit and allows you to move the whole combination in relation to the subject matter.

Apart from these aspects, which are important for focusing, you should consider the ease of handling of a bellows unit. Simple models provide nothing but the extension between lens and camera, while more advanced (and complicated) models couple some, or all, automatic features of camera and lens. But this does not mean that the latter are always more convenient! If you work with magnifications of greater than life size, you will have to reverse the lens (or use special macro lenses without automatic features) so that having thus disconnected the auto linkages you have to work in the manual mode anyway. For this, a simple model would be better, because it is

Fig 2 This bellows unit is unusual in that it allows the lens axis to be adjusted in relation to the film plane either by adjustment of the camera body or the lens itself. Lateral or vertical shift, tilt and swing movements provide the range of movements normally available only on large format cameras.

29 This is the part of the camera that you never see — unless it is involved in a serious accident! The interior picture of a Pentax LX camera was photographed with another Pentax LX using a ringlight and automatic exposure. A subject at this scale would come within the range of a table tripod or small copy stand with a removable stage plate.

cheaper and less bulky and heavy.

An exception to this are those bellows units which allow you to turn the front standard through 180° and couple the bellows to the front element of the lens, so that automatic stopping down is preserved even with lenses in the reversed position.

A special ring with double cable release may be fitted to some reverse mounted lenses to enable the diaphragm to be closed down at the moment of exposure. This, however, adds to the bulk of the lens end facing the subject.

Copying stands and adapters

Most 'system' reflex camera manufacturers offer slide copiers and small copying stands as additional equipment. The slide copiers will be discussed later, but a few words on copying stands might help you to decide whether or not you might use one. A typical unit of this kind is shown here. It has a definite advantage over more elaborate arrangements.

Although being very small and light, it is quite rigid, because of its firm mounting on the focusing rail. The object stage, which usually consists of a piece of grey plastic or glass, and the camera, are directly connected, so that any movement would affect both at the same time and thus minimise the risk of blurred pictures.

Another interesting feature is the removable stage plate. If, for example, you want to photograph insects on the ground (like ants) or on tree trunks, you can set up the whole arrangement of camera-bellows-lens-copying stand (less stage

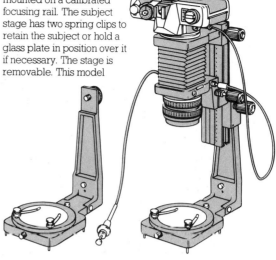

Fig 3 Copying stand (or 'macro stand') for small scale subjects. The camera and bellows unit with adjustable front and rear standards is mounted on a calibrated focusing rail. The subject stage has two spring clips to retain the subject or hold a glass plate in position over it if necessary. The stage is removable. This model allows simultaneous lens diaphragm and shutter operation.

plate) and prefocus it on the ground. Then you can simply set it down where you may need it without having to make any further adjustments of the camera.

Many manufacturers offer stands designed for copying work from medium-to-large sized originals. These take the form of a table with four legs supporting the camera vertically over the original, or a vertical column with a bracket at right angles to support the camera at the required distance. Alternatively, some enlargers allow the whole head section to be removed and replaced by a camera bracket, so converting the enlarger column and baseboard into a copy stand.

Lens mount adaptation

In addition to the equipment already mentioned many camera manufacturers offer adapters which allow you to use lenses other than those of their own brand. This is quite important, because sooner or later you might want to use special

30 One-inch wood screws photographed with a macro lens and ring flash illumination. A medium sized copy stand would be suitable for this type of work. Ring flash can penetrate a subject in depth where oblique lighting would not, and there is no risk of shadows from the stand.

31 This shell of a sea-snail was roughly sawn in half with a fretsaw and then smoothed with fine-grain sandpaper. Magn. 0.5 X, 50mm lens on bellows unit, focusing rail, mounted on copying stand. $f/16$, 2 sec, continuous artificial light (fibre optic) source.

macro lenses, microscope objectives or lenses with a C-mount (a standard thread for certain types of lens), for some special application. If the manufacturer of your camera does not offer a special adapter for this purpose, you might still be able to obtain one, which has the camera mount (bayonet) on one side and on the other a standard 42mm thread. This M42 thread was at one time used on many cameras, but still has its uses, because a wide variety of adapters are available with this kind of thread.

I will give you two examples:

1 Suppose you want to use a special macro lens of the Luminar or Photar type with your camera. These lenses have a standard microscope thread, which will obviously not fit into the bayonet mount of your camera. Although the manufacturers of these lenses offer adapters for the major brands of cameras, yours might not be among them. Then you have to proceed as follows: attach the lens to an adapter with an M42 thread on the rear end (these are available from some independent manufacturers as well as from the manufacturers of the lenses) and combine this with the M42 adapter, which is provided by the manufacturer of your camera.

2 For the second example let us assume the worst case, that is, that your manufacturer does not offer an adapter at all. In this event you could use the smallest extension tube available to make up your own. A mechanic could easily (and relatively cheaply) attach an M42 adapter to it or even a simple metal plate with a microscope thread in its centre. One must not necessarily be too finicky here. Although a mechanic would not recommend this procedure, I have found that a piece of plastic, some two-component adhesive such as Araldite and black laquer will carry you a long way. Small misalignments of the lens (slightly off-centre or marginally tilted in relation to the film plane) are of no consequence in most applications of close-up photography, because you adjust the focus by visual inspection.

Home-made constructions of this kind do not work, however, in cases where absolute parallelism between film plane and subject is required, as in reproduction work of very small scale objects (for example stamps), where even a very slight misalignment would become apparent in the picture.

Focusing mechanics

How to recognise on the screen whether you have focused properly or not may become quite a serious difficulty and I shall discuss that later. Here I am concerned with the purely mechanical question of how to adjust the camera for proper focusing.

In general photography, the usual procedure is to adjust the distance (extension) between the lens and the camera to the amount required for the distance between lens and subject matter. In close-up photography this is not really practical because a change in the extension also alters the

magnification. If the subject were then too large or too small you would need to adjust the lens-to-subject distance again and refocus, possibly repeating the whole process several times before the correct sized image were obtained in focus. In close-up work it is best, first, to decide on the magnification to be used and set the extension (bellows, tubes) accordingly. Then you adjust the distance between lens and subject matter by moving the whole unit towards or away from the subject. For this you obviously need a focusing rail, which is therefore not only necessary for the use with bellows, but also with extension tubes and even with macro lenses.

This method is not only the easiest, quickest and least fussy way to focus, in some cases it is even the only one. If you want to use an exact magnification the extension is determined by it and cannot be changed anyway. But even when taking hand-held shots, the extension should be pre-set and correct focusing achieved by changing the lens-to-subject distance. In many cases, especially with living subjects, you are likely to lose valuable time by adjusting adjustments and clamping clamps—the butterfly or whatever is not going to wait until you have finished fiddling around.

About the only exception to this practice would be if you had one of the special follow-focus units with which focusing can be done so quickly that a continuous adjustment of the extension is possible.

Fig 4 Two possible arrangements for adapting a lens with a microscope thread to your camera if no direct adaptor is available. **A** Bellows front standard thread or bayonet — M42 adaptor-microscope thread-lens. **B** Bellows front standard thread or bayonet — extension tube-plate (glued) with microscope thread-lens.

Fig 5 A In normal photography focusing is usually by adjustment of the lens-to-film distance according to subject range. **B** In close-up photography it is more convenient first to set the lens-to-film distance for the desired magnification and then move the whole camera and lens assembly forward or back from the subject to obtain the best focus.

Fig 6 Adjusting focus on long focal length lenses can sometimes be cumbersome and slow, especially when 'hunting' moving subjects such as small animals. This 'follow-focus' or 'quick focus' device allows sudden changes in focus to be made. With its built-in extension tube it can provide magnifications up to one-third life-size. Interchangeable lens heads of 200, 400 and 600mm focal lengths are available.

7 LENSES FOR CLOSE-UP PHOTOGRAPHY

A variety of lenses are specifically made for use in the close-up range, while others may be advantageously adapted for this purpose, even though they are actually intended for different applications. I will start by describing those especially designed for close-up photography and later will turn to more out-of-the-way equipment.

Bellows lenses

Some manufacturers offer lenses which are called 'bellows lenses' or 'bellows heads'. These lenses do not have a focusing movement and can therefore only be used on a bellows unit (or for fixed magnifications on extension tubes). Typically, they come in focal lengths of 50 or 100mm. Mounted on a bellows of average extension they will cover the whole range from the infinity setting up to life size (with 100mm) or 2 x (with 50mm).

So a 100mm lens of this type would cover the same range as a macro lens of this focal length (see below). The main differences are these: due to the lack of a built-in focusing movement and the peculiar optical construction (no retrofocus design) these lenses can be quite small, light in weight and inexpensive, although it should be stressed that their optical quality is not impaired by this seeming simplicity. The drawback is that such lenses must be operated in the manual mode and that for exposure measurement the working aperture must be used with TTL metering.

The extreme range of focusing distances possible with a bellows lens is much more easily and elegantly achieved with a macro lens. But apart from being quite bulky and heavy in comparison, the latter can be several times more expensive than the bellows lenses. Therefore bellows lenses offer quite an interesting alternative for the close-up photographer of modest means.

Apart from this, they have another very interesting application outside close-up photography which I would like to mention nevertheless. They can be used in the infinity setting together with the special fully adjustable bellows described in the previous chapter, so that you have practically all the movements of a view camera available for a 35mm SLR.

Macro lenses

If we were to stick to the nomenclature given in the first chapter, these lenses should actually be called close-up lenses because they are designed for magnifications of up to 1 x (where, as you will remember, the true macro range starts!). But as this is what they are usually called, we will keep to this tradition.

Most manufacturers offer macro lenses in two focal lengths, a shorter one in the 50mm and a longer in the 100mm range. The main feature of their mechanical construction is a very long focusing movement. In some cases the thread is so long that continuous focusing from infinity to 1 x magnification is possible. But more often, the lens focuses continuously up to 0.5 x magnification, while the range between half-life-size and life-size is covered by an additional extension tube (belonging to the lens).

This division is quite practical, because a magnification of 0.5 x is considered about the limit for hand-held available light photography, while greater magnifications in most cases require artificial lighting (flash) or the use of a tripod. In my opinion a macro lens with additional extension tube is to be preferred. It is less bulky and the mechanical parts seem to be more durable.

As far as the optical quality is concerned, macro lenses are specifically corrected for optimum performance (especially for a flat and distortion-free image field) up to 1 x magnifications. This accounts for their relatively small maximum aperture (in most cases something like $f/3.5$). This sacrifice has to be made, otherwise their optical correction could not be as good as it is.

Nevertheless, this maximum aperture is, in my view, sufficient for these lenses to be used for pratically all purposes so that standard lenses of the same focal length are not necessary. If you buy a new camera system, you should take that into account. The only question to be solved in this context is whether you would be better off with a lens of the 50mm or the 100mm type.

The main difference in the application of these lenses lies in the distance between the front lens element and your subject matter, in other words, the working distance. The following table shows a typical example:

7.1 Working distances for two typical macro lenses

Magnification	0.2 x	0.5 x	1 x
Macro lens 50mm	24.7cm	9.8cm	4.7cm
Macro lens 100mm	56.5cm	26.2cm	16.2cm

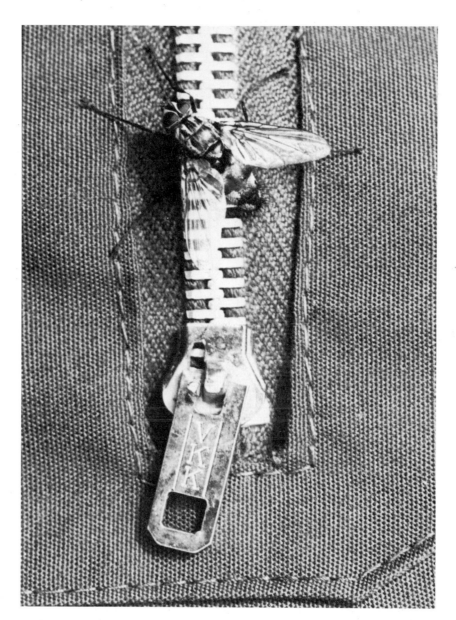

32 Quickly seized shots in the close-up range require equipment that is easy to handle. If you carry a 100mm or 50mm macro lens instead of the 'normal' one of the same focal length, situations like this will not escape you. Magn. 0.5 X, 100mm macro lens, *f*/16, 1/250 sec, available light.

33 and **34** Both photographs have been taken with a 50mm bellows head at a magnification of approximately 0.5 X. Although the same subject, the impression given by these two pictures is very different due to differences in viewpoint, lighting and depth of field. **33**: *f*/11, 1/125 sec, **34**: *f*/22, 1/15 sec. Other data: 50mm bellows head, magn. approx. 0.5 X, camera on tripod, wind shield.

This table shows that the 100mm lens would be preferable if you are mainly concerned with photographing small animals, because here it is essential to have the greatest possible working distance. Another advantage is that, in addition, the greater the working distance, the easier it is to arrange artificial lighting.

But if a decision in favour of the 100mm type of lens now seems to be a foregone conclusion, you should take into account that in some cases these long distances can be a hindrance as well. Most slide copiers are meant to be used with a 50mm macro lens and it would be practically impossible to set them up in the usual way (that is, in the combination of camera-bellows-lens-slide copier) with a 100mm lens. Additionally, most reproduction and copying work must be done with a 50mm lens, because the working distances involved with a 100mm macro lens would exceed the mechanical limits of most copying stands.

Therefore a decision to buy one or the other of these lenses should be made along the following lines. If you are mainly concerned with copying work (including slide copying) and reproductions, you should stick to a 50mm macro lens. On the other hand, if you are more interested in general close-up photography (small animals, plants, and natural scenery in the close-up range) you would be better off with a macro lens of the 100mm type.

But whatever your decision, you should take note of the following advice. Macro lenses are corrected for magnifications up to 1 x. If you want to use them on your bellows for greater magnifications, they will have to be reversed like other lenses. But then they should deliver a better performance than standard lenses used in the same mode.

The other thing which you will have to take into account when using macro lenses on tripods and copying stands is that a focusing rail is virtually essential.

Although focusing can be done by moving the whole assembly of camera and tripod this is not really practical. So you should add a focusing rail to your equipment even if you do not have a bellows unit. Most manufacturers offer these as an optional accessory.

Special macro lenses

Some manufacturers offer special macro lenses to be used exclusively on bellows and for magnifications of more than 1 x (up to 30 x). These lenses

may be integrated into the manufacturer's camera system, but some of them can be adapted to practically all available cameras, including medium format and view cameras.

Before I begin a description of these lenses and their uses I should mention that they are definitely your best buy if you want to go for high magnifications. Apart from the various advantages set out below, they are relatively inexpensive. A special macro lens of 12.5mm or 25mm focal length would, for example, cost about half as much as a first-rate macro lens of the kind I have previously described.

Mechanically speaking, these lenses are versatile because they have the international RMS microscope-thread (W 0.8 x 1/36 in) and can thus be used on microscopes and—with the appropriate adapter—on practically all cameras. They are made in various focal lengths from 12.5 to 100mm and are available from the following manufacturers: Zeiss (Luminar: 16-100mm), Leitz (Photar: 12.5-100mm), and from Nikon, Minolta, Olympus and Topcon in different focal lengths.

These lenses do not have a focusing movement, have to be used in the stopped down mode and do not have a built-in shutter, which means that you need an additional auxiliary shutter for all cameras without a focal plane shutter (auxiliary shutters are available from some manufacturers of view cameras).

The main advantage of these cameras is, obviously, that they have been corrected for high magnifications, which means not only an optimum image quality but also that you do not have to stop them down for best possible performance. Additionally, they are quite fast (the Leitz Photar 12.5mm has a relative aperture of $f/1.9$, which can really be used for taking pictures!), so that the necessary exposure times can be quite short despite the high magnification involved. An example: for a magnification of 5 x with a macro lens of 50mm focal length in the reversed position, you would need an extension of 200mm and a relative aperture of $f/8$ for optimum image quality. With a 12.5mm Leitz Photar lens the same could be done with an extension of 50mm and $f/1.9$!

The magnifications possible with these lenses depend on the smallest and greatest extension of the bellows used and on the length of the adapter-ring (furnished either by the camera or the lens manufacturer). Therefore the following table can indicate only the approximate values for use with most 35mm cameras.

7.2 Magnifications possible with different length lenses

Focal length	12.5	25	40	63	100 (mm)
Min. magn.	8	3.2	0.63	0.13	0.23 x
Max. magn.	20.5	9.3	3.7	2.1	1.1 x

Apart from the obvious combinations with bellows, these lenses can be mounted directly on the camera (via the appropriate adapter) or on extension tubes for fixed magnifications. A very interesting combination is, for example, a lens of 25mm focal length, mounted with adapter directly on the camera body. With my camera, this combination yields a magnification of approximately 2 x. It is very small, light in weight and easy to handle. I have even used it successfully for hand-held available light photography of small plants and insects. Combined with flash, this unit can be used as an all-purpose instrument for 'hunting' very small insects, the only drawback of course being the fixed magnification. But this actually poses no problem whatever if you concentrate on one kind of subject at a time.

Microscope objectives
It has already been said that the special macro lenses described above have a standard microscope thread. As a matter of fact the main difference between a normal microscope objective and these lenses lies in the fact that the latter have an iris and can be stopped down, while microscope objectives have a fixed opening only. Nevertheless microscope objectives are eminently suitable for certain close-up applications off the microscope as long as you use the plana-chromatic or apochromatic types. (Standard microscope lenses yield only an inferior image quality and should not be used for photographic purposes at all on or off the microscope.)

If you want to try microscope lenses, you should choose the low-power ones. A 6.3 x /0.16 microscope objective would be the approximate equivalent of a $f/3.0/25mm$ special macro lens, while a 16 x/0.35 would equal an $f/1.4/10mm$ lens.

Due to the lack of an iris and the very small working distances involved the use of microscope objectives is practically limited to flat objects illuminated from behind. But here they will yield excellent results.

Enlarging lenses
Most enlarging lenses have a screw-in thread or an adapter for the 39mm diameter so-called Leica thread. Some manufacturers offer adapter rings for this kind of thread, so that these lenses can be used for close-up photography as well. This is not as far-fetched as it may sound, because enlarging lenses are designed for use in conditions not dissimilar to those in close-up photography so that their application can result in a better image quality than that from lenses for general photography. Due to their special correction for the close-up range they can perform well without being stopped down and even without being reverse-mounted.

If you should, for example, have a $f/2.8$, 50mm enlarging lens which can actually be used with this f-number for enlargements, then you will probably find that this same aperture setting is extremely good for taking pictures as well. (But watch the manufacturer's specifications, sometimes the widest aperture is meant for focusing only.)

An enlarging lens of 50mm focal length could be used for magnifications from about life size up to 3 x, depending on the extension of the bellows used. There is a minor problem with some modern enlarging lenses—illuminated f-stop scales. These openings have to be carefully covered. You can do this yourself by placing some layers of black adhesive tape over the opening(s) in the interior of the lens (to try covering the transparent f-number scale itself would be quite difficult!) In certain cases this safety measure is superfluous because some camera makers offer special adapters for use with their own enlarging lenses which provide this feature automatically.

Note, however, that although some enlarging lenses can be focused to infinity, they should not be used for general photography (as, for example, the bellows lenses, mentioned previously) because they are not corrected for this range.

Cine lenses (for 16mm cameras)
In some older manuals on close-up photography you will find advice on using 16mm movie camera lenses for close-up photography. It can, indeed, be done because this type of lens usually comes in quite short focal lengths and some manufacturers offer adapters which allow you to combine C-mount (the standard for slide lenses) with your camera.

But these lenses are corrected for general photography and should be used only in the reversed position for close-ups. The problem then is one of adaptation, because as far as I know

there are no commercially available reversing rings for these lenses that can be used on 35mm cameras.

Nevertheless, it could be worthwhile investigating this problem and perhaps having a suitable adapter made because some brands of 16mm movie camera lenses have a very useful property for close-up work—they are of retrofocus design. As we have already seen, if you use retrofocus lenses in the reversed mode, the minimum working distance (that is, the distance between the rear lens element, which in this case is turned toward the subject, and the subject matter) is never smaller than the distance between the rear lens element (in normal position) and the film plane at the infinity setting. With C-mount lenses, the latter is exactly 17.52mm. This would then always be your minimum working distance with a C-mount lens in the reversed mode, irrespective of the magnification.

With a Luminar lens of 16mm focal length the working distance is already smaller than this with a magnification of approximately 3 x, while with a 25mm Luminar lens, this limit would be reached with a 6.5 x magnification. In contrast to that, a retro-mounted C-mount lens of, say, 15mm focal length, could be used at magnifications up to 20 x (on bellows) and still have this working distance of 17.52mm.

Although this may be quite irrelevant in general close-up photography (especially so because the image quality, though good, would not equal that of the special macro lenses described previously), it may come in handy if you are specialising in photographing very small live animals and related subjects.

Zeiss Tessovar system

After I have described various lenses, which can be used for close-up photography and have indicated a few of the problems you are likely to meet (other problems will be discussed later), I would like to mention a special lens (plus accessories) which does not pose problems like some of those previously discussed but solves them—except for one. By comparison with other equipment so far mentioned it is extremely expensive. For a complete and elaborate version you could buy a new car and even a stripped-down, 'economy' model would be three to four times as expensive as the most expensive 35mm SLR you can think of!

The Zeiss Tessovar is intended for scientific applications, mainly in an industrial or institutional

context, but an amateur photographer specialising in close-up photography might be tempted by it as well if he has a large budget. It can be used for object sizes ranging from about 60 x 90mm to 1.5 x 2mm, which equals magnifications of 0.4 x to 12.6 x for 35mm cameras. It is suitable for all formats up to 9 x 12cm and the magnifications are accordingly higher. Its main features are as follows:

1 It has four generous fixed working distances.
2 The magnifications mentioned above are covered in four ranges. In each of these ranges you have to focus only once, changes in magnification within this range are effected by a zoom lens element.
3 Magnifications are indicated on a scale, you do not have to calculate them.
4 Exposure corrections are unnecessary, because the iris is automatically adjusted when you change magnification. This has two advantages: **a** the exposure (lighting, flash distance) can be the same for all magnifications **b** you always have the same optimum *f*-stop, which balances depth-of-field against the inevitable diffraction (see Chapter 1). Nevertheless you can adjust the iris manually, if you should feel so disposed.

In addition to this, Zeiss offers a variety of film-backs, adapters for 35mm cameras, viewers, an automatic exposure system, focusing rails, stands, object stages, lighting systems and so on, which leave nothing to be desired—in short, a wonder system if you can afford it.

As I have already said, such highly specialised machines do not do anything that could not be done by simpler means as well—but they allow you to do it easily and efficiently.

35 A 25mm Photar lens on a bellows unit was used to produce this picture, which shows a cross-section of a twig of Aristolochia at a magnification of 4 X. The subject is actually a microscope slide, bought ready-made. Aperture: *f*/4 (approximately, these lenses do not have click-stops), 2.5 sec. The camera was mounted on a copying stand. A slide viewer with its lens removed served as a trans-illumination light source.

8 OTHER METHODS OF CLOSE-UP PHOTOGRAPHY

Apart from the more or less orthodox ways of taking close-up photographs which I have described so far, there are a few other possibilities which I would like to mention, although without going into great detail. But it should be quite easy for you to investigate them yourself, if they happen to arouse your interest.

Using the enlarger

An enlarger can well serve as a 'reversed camera' for close-up photography of translucent and/or transparent objects. The procedure for this is quite simple: you just place the object to be photographed in or on the negative carrier of your enlarger (or on a plate of glass on top of a glassless negative carrier). Then you focus it on the easel and enlarge it in the usual way either on photographic paper or on sheet film (for example, orthochromatic film which can be handled under convenient safelighting). This can then in turn be enlarged or contact-printed on paper, resulting in a positive image.

The enlargements possible with this technique (in this case 'enlargement' and 'magnification' would be the same; see Chapter 1) depend on the construction of your enlarger. My enlarger, for example, allows magnifications (enlargements) of up to 17 x on the easel.

Although the object thus treated will have to be translucent or transparent, the choice of subject matter is probably wider than you think. It includes, for example, small blooms and leaves (which are either translucent or can be treated in some way to become so), liquids, crystallisations, glass objects, microscope slides and so on. This technique belongs at least partly in the field of photograms and you will find more information in the appropriate books.

Another method of making high-magnification close-ups with the enlarger should be mentioned here. The set-up is as follows: the camera (without lens) is placed on two blocks (cigar boxes would do) on the enlarging easel so that the opening which usually contains the lens faces upwards. An angled viewfinder is attached to the camera. If you now place an object in the negative carrier of the enlarger as described above, it can be focused on the film plane (check by looking through the angled viewfinder) and photographed. You can even use the automatic

Fig 7 An enlarger and camera combination for photographing transparent objects. The camera, with lens removed and fitted with an angle viewfinder, is positioned on the enlarger easel with its lens port facing the enlarger head and in the centre of the projected image area. The camera body is supported either side to give clearance for the viewfinder. A subject is placed in the negative carrier. As the enlarged image is projected into the focal plane of the camera, focus is adjusted by inspection through the camera viewfinder.

exposure system of your camera (a test-run is necessary to determine corrections). If your enlarger allows magnifications up to, let us say, 17 x, this will be the maximum magnification of the object on the film. If you enlarge this negative again, the maximum enlargement of the object on the print will be 289 x! The enlarger light source must be fully diffused, otherwise a hot spot may appear in the centre of the picture area. Condenser enlargers may be diffused sufficiently by inserting an opal sheet in the filter drawer. With colour, the light source and film may need to be balanced with filtration.

Stereo microscope

If you are mainly interested in high magnifications, a stereo microscope might be a good solution to your problems. Up to a very short time ago, most of these instruments offered only the possibility of attaching a camera with standard lens (set at infinity) over one eyepiece by means of a special adapter. But more recently well-known manufacturers have introduced reasonably priced stereo microscopes which allow you to attach a camera via a third tube, so that the optical and mechanical qualities of such combinations are really excellent.

The smallest magnification possible usually lies in the 2 x range, while some instruments offer magnifications of up to 300 x, which is well into the photomicrography range.

Stereo microscopes have three disadvantages, the first being that even the smallest magnification is quite considerable. The second is that they are practically stationary (although this is almost mandatory with the magnifications in question) and the third is that only the more expensive models have an iris built into their photo-tube. As already indicated in our discussion of microscope objectives, this really is a great disadvantage. So you should either choose an instrument which offers this possibility or you should investigate whether the construction of your instrument allows you to use home-made irises. It is, for example, perfectly possible to use as irises small discs of black paper which contain holes of varying diameters. These can usually be inserted somewhere in the tube which carries the camera.

Against these disadvantages, stereo microscopes have many advantages that are important for close-up photography at high magnifications. They have built-in precision focusing rails, they are rigidly constructed, they often have built-in

spotlights and transillumination or even mechanical object-stages and, last but not least, they usually afford very great working distances.

A home-made photo 'macroscope'

I have borrowed the name 'macroscope' from some special equipment for stationary photography with magnifications from 1 x to 50 x, which is meant for professional use and costs (depending on the choice of accessories) as much as a family car. The instrument, which I made myself, cost one fiftieth of that (less camera and lenses, which I already had) and works fairly well for magnifications from 2 x up to 40 x.

Its main part is a microscope, which I bought secondhand. This provided the object stage and the very fine and precise focusing rail. A separately bought mechanical stage was glued to the object stage with a two-component adhesive and instead of the tube carrying the eyepiece, a small extension tube was glued on top of the microscope stand. Both of the operations required filing off protruding pins and screws, but this was not difficult to do. The microscope accepts my Luminar lenses instead of the microscope objectives and the camera with bellows can be attached to the extension tube on top. The whole set-up was fastened to a copying stand (Fig 7).

It may look a bit strange, but it works perfectly well and is easy to handle. Assembling it was easy as well; finding the necessary parts as cheaply as possible presented much more of a problem. But I think it was worth it, because this probably represents the cheapest way to acquire (almost) professional equipment for close-up photography with very high magnifications.

Rangefinder camera

Rangefinder cameras with fixed lenses are not ideal for close-up photography, but they can be used for moderate magnifications with supplementary close-up lenses. The problem of focusing can be overcome in two ways: some manufacturers offer either copy stand systems or field frames to go with special close-up supplementary lenses, while others provide units which combine these lenses with a prismatic correction device, which adapts the rangefinder of the camera to the smaller focusing involved, at the same time correcting the parallax between rangefinder and lens.

Rangefinder cameras with interchangeable lenses can, of course, be used with the same

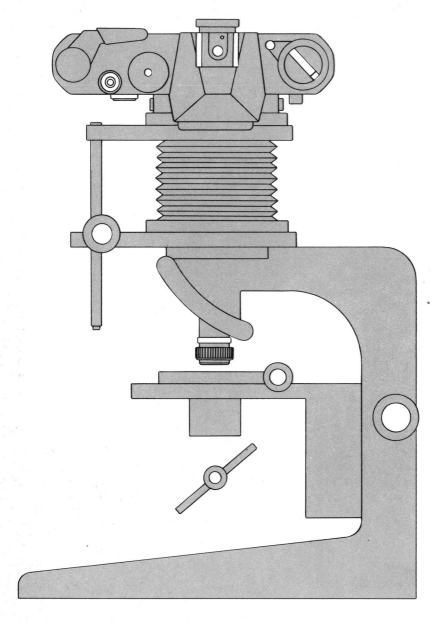

Fig 8 Macroscope modification of a disused microscope for working in the macro range. The camera, fitted with a bellows unit, but without lens, is mounted on to a microscope by a small extension ring and two-component adhesive. The microscope lens is replaced by a macro lens of the Photar or Luminar type.

36 The subject of this and the following photograph is very interesting. A glass plate was covered with soot (using a candle) and spirit was then dropped on to the surface (turpentine can be used). The glass plate was then placed in the negative carrier of the enlarger and enlarged directly on to photographic paper. (Enlargement 10 X).

accessories, but they offer the additional possibility of attaching a mirror housing (the Leica Visoflex), which actually changes these cameras into SLR cameras (latest models have TTL metering).

Twin-lens reflex cameras

If necessary, TLR cameras can be used in the close-up range as well. There are devices similar to those described above, which combine close-up supplementary lenses with prismatic elements for the correction of parallax. A special case is the Mamiyaflex (two slightly different models) which at the time of writing is the only TLR camera with a built-in bellows and interchangeable lenses, allowing magnifications up to 1 x. Here the problem of parallax is solved in a very elegant way by means of a 'paramender', which is placed between camera and tripod so that immediately before taking a picture the camera can be simply raised or lowered by the amount separating the viewing and the taking lens, bringing the taking lens into the exact position previously occupied by the viewing lens. Obviously a device of this kind can only be used for stationary subjects.

37 The same subject is shown here, but in this case the image was projected on to the negative in the camera body, which was placed directly below the enlarger, as described in the text. (Magn. 10 X, enlargement 10 X).

38, 39 Both photographs have been taken with the home made 'Macroscope', described in the text. They are taken at magnifications, which would be very difficult to achieve with normal bellows units. The extremely small insect (Ixodes ricinus) in Ill. **38** is a readily prepared microscope slide. Magnification 11 X, transillumination with fibre optics, 12.5mm Photar, *f*/5.6, 4 sec, camera with angled viewfinder on 'macroscope'. Illustration **39** shows the eye of another insect (hornet), which I found dead in my garden. Magn. 14 X, 12.5mm Photar, incident light with fibre-optics, other data as quoted above.

9 VIEWING SCREENS: FOCUSING AND MAGNIFICATION

In our general discussion of equipment I have already stated that the camera most suitable for close-up photography would have interchangeable viewing screens. The main reason for this is that the usual kind of viewing screen with a split-image and microprism rangefinder is not very suitable for close-up photography and becomes almost impossible to use with high magnifications. Microprisms and the split-image field simply become dark and therefore impossible to work with. The grain of the mat screen becomes so pronounced with high magnifications and the consequent darker image, that it interferes with and actually prevents precise focusing. In cases of this kind you will need special focusing screens.

But before I turn to those, I want to describe a general property of all viewing screens, which can be helpful in all ranges of close-up photography.

Determining magnification

We have already seen in the first chapter that it can be a very tiresome business to calculate the amount of magnification used in a given set-up. It is much simpler to measure it. This can be done by using several places on the viewing screen as reference points.

The viewing screen of the camera which I generally use for close-up photography has, for example, the overall dimensions 23.5 x 35.3mm. If I were to use a screen with microprisms, those would occupy an area with an outside diameter of 13.8mm. By placing a ruler in the picture plane (after focusing!) it is easy to determine magnification by a comparison of these measurements, with the following calculation:

$$\text{Magnification} = \frac{\text{Distance on viewing screen (mm)}}{\text{Distance on ruler (mm)}}$$

Suppose when looking through the viewfinder you can see 17mm on the ruler on the short side of the screen. Then in this case

$$\text{Magnification} = \frac{23.5 \text{ (mm)}}{17 \text{ (mm)}} = 1.38 \text{ (x)}$$

Although this is quite simple and straightforward, you can run into some difficulties, the first being that the manufacturer of your camera may not state essential screen measurements. If so, you can decide them yourself by simply measuring the appropriate dimensions, which unfortunately only works if you can remove the screen from the camera. If not, you will have to use a macro lens, which has the magnifications for various extensions engraved on its barrel, in the 1:1 (1 x) setting, so that you can directly measure the dimensions of the viewing screen, by placing the ruler in the plane of sharpest focus.

The second problem you might encounter is that with an ordinary ruler it becomes quite difficult to determine the exact measurements when using high magnifications. If you often work in this range, you can buy an object-micrometer (a small glass plate with a very exact scale engraved on it) which is sold as a microscope accessory.

This way of determining magnification is independent of the equipment used; it works with bellows, extension tubes, lenses of all kinds, supplementary lenses and whatever else you may happen to fancy.

Focusing screens and their use

I have already said that a normal viewing screen with microprisms and split-image spot is not suitable for close-up photography because these viewing aids simply go dark and then obscure the central area of the image. The obvious substitute therefore would be a matt fresnel type viewing screen without any viewing aids or—if you go in for a lot of reproduction work—the same, but with a scale or a chequer-board pattern of lines. This helps with lining up the camera straight and square-on to the subject, but can also serve for the simplified measurement of magnification just described.

This type of viewing screen actually works quite well for standard photography too. But it has drawbacks in common with ordinary matt screens when very high magnifications are involved—the grain of the matt screen becomes so pronounced

40, 41 If you have looked carefully at the preceeding pictures you will have noticed that many of them were done with the help of an angle viewfinder. A magnifying or focusing hood would serve the same purpose for a medium format camera. Both illustrations: Magn. 1 X (6 x 7cm camera), f/22, 1/60 sec, camera with magnifying hood, miniature tripod, extension tube. Both subjects were taken from ground level.

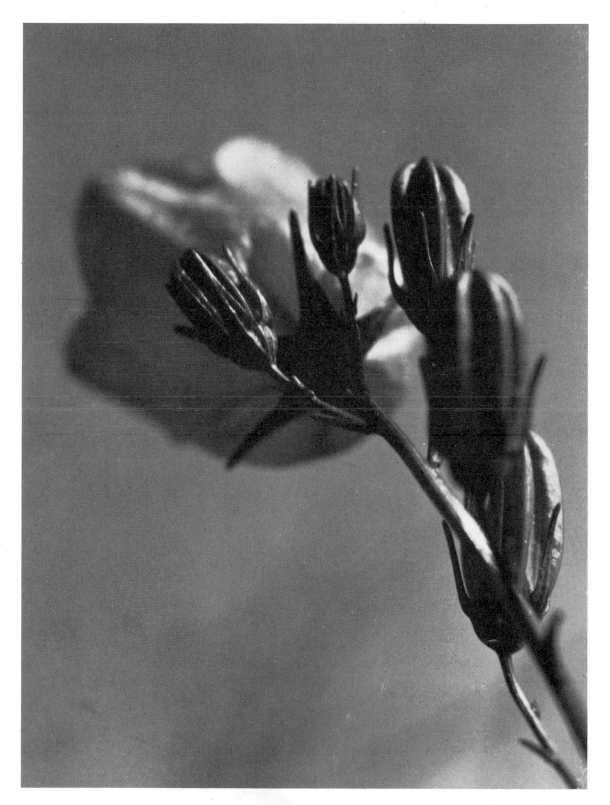

that it is practically impossible, or at least very difficult, to focus properly. The best alternative is a clear screen with an etched double cross. These are usually made in two versions, one is a matt fresnel screen with a clear central area spot and etched double cross. The other is a completely clear fresnel screen with double cross.

Although the latter seem to be more attractive because they provide a clear and bright image throughout, they have a distinct disadvantage. In many cameras where TTL meter readings are taken from the screen, measurement will be influenced by the type of screen used. If the meter reads independently from the screen (eg. in the light path from the lens, or from the film plane) the type of screen chosen makes no difference.

Apart from that, all of these viewing screens are used in the same way. That is, the sharpness of the image is determined by a comparison of the image itself with the etched double cross. (You cannot focus *on* the screen in the usual way, because being clear, it has no visible surface on which the image is rendered.) You are focusing, in effect, on an aerial image. This can be done in two ways, by the parallax focusing and the dioptric focusing methods. Both require a view-finder magnifier in order to work properly, which can either be attached to the normal finder or exchanged for it.

Focusing by parallax

Parallax focusing is done in the following way. Provided that the viewfinder magnifier is adjusted properly, to focus on the screen surface, you start by roughly focusing the object which you want to photograph on the matt part of the screen. In the clear part of the screen you will now see the image of the object and the double cross, both more or less clear and sharp. If you move your head slightly you will notice that the image, too, moves in relation to the cross—the more so the more it is out of focus. You then have to change the lens-to-object distance (or the extension) until both image and cross no longer move in relation to each other when you move your head.

This procedure probably sounds quite strange to you if you have not tried it yourself. But it is actually quite simple to do and very precise. So you can get used to it.

Dioptric focusing

You might prefer, on the other hand, the dioptric method, although I personally have always found

it more difficult to do. For dioptric focusing you start in the same way as described above and focus the object roughly. Then you proceed by looking at the cross and, after that, quickly transfer your gaze to the image. If it takes the eye some time to refocus until the object looks sharp, the image is still out of focus. You can do it the other way round and concentrate on the image first. If the cross then looks blurred, you have to refocus. When both image and cross appear at the same time, so that no re-adjustment of the eye takes place when looking from one to the other, you have focused properly.

Although I do not find this method as con-venient as parallax focusing, this may be the result of a personal idiosyncrasy. You should test both methods and settle for the one which suits you. Some people use both methods alternately because it is said that parallax focusing works best for magnifications up to 5-6 x, while dioptric focusing is better for higher magnifications. But, again, you should test this for yourself.

Interchangeable viewfinder and angle finder

Most cameras with interchangeable viewing screens have interchangeable viewfinders as well. This is quite an important feature, because there are very frequent occasions in close-up photography where you cannot use the normal prism finder. Many, or perhaps even the majority of close-up subjects may be close to the ground or some other surface. With the camera at a low angle you really need to look through the view-finder from above. Another common set-up is the vertical arrangement of the camera for high magnification, reproduction and related work, which makes normal viewing impossible. (This is also true for set-ups with microscopes, stereo microscopes etc.)

In those and similar cases the normal view-finder should be exchanged for one of the waist-level type or, even better, for a high-magnification finder, which may magnify the screen image by up to 5 x.

If your camera does not offer interchangeable viewfinders you can use instead an angled finder, which is attached to the eyepiece of the normal viewfinder. This allows waist-level viewing as well and is in my opinion one of the least dispens-able accessories for close-up photography.

10 AVAILABLE LIGHT

Before we can start discussing lighting and light sources, we will first have to look at a seemingly entirely different problem, which nevertheless governs our decisions concerning the lighting— or at least should do. I have explained elsewhere that, photographically speaking, light is not only a quantity, but a quality as well.

You can, for instance, take a very impressive photograph in which the subject is quite difficult to recognise: for example, something like a strongly backlit scene, which results in silhouettes. On the other hand, you could usually photograph the same subject in another kind of lighting, which would reveal all its details but may, nevertheless, result in a boring picture.

These problems apply equally to close-up and general photography. We can divide close-up photography, roughly speaking, into two categories—the scientific and documentary approach on the one hand and the creative (or, if you want to go that far, the artistic) approach on the other.

The main consideration in scientific or documentary photography is the information you want to impart to anyone looking at your pictures. Everything in this kind of picture, therefore, has to be subordinated to the production of clear, unequivocal and easily recognisable information.

In creative photography on the other hand the important thing is your idea, the impression or feeling you want to convey to a person looking at your work. If, during this process, the subject matter becomes partly obscured or even completely unrecognisable, this does not signify anything.

It should actually go without saying that both kinds of photography usually require entirely different kinds of lighting. My experience has led me to believe that the documentary or scientific approach more often than not results in the application of artificial lighting, which may be needed to enhance detail, stop movement, show surface structure, provide transillumination and so on. On the other hand my own brand of creative photography (which may not necessarily coincide with your ideas on this subject!) involves almost exclusively the use of available light, as far as outdoor close-up work is concerned, because in this kind of photography I am more interested in the situation I find than in the objects themselves.

Lighting is a very important factor in the impact of your picture on the viewer and should therefore be considered most carefully, although this tends to be overlooked in close-up photography because it is often difficult enough just to get sufficient light.

Using windshields and fast films
Even if the available light is more than enough for general photography, exposure increases made necessary by magnification often result in very long exposure times.

For that reason, and because of the proportional increase in subject movement, tripods, stands and clamps of all kinds are especially important for obtaining good quality results in available light close-up work.

The movement of plants and inanimate outdoor subjects of all kinds can be stopped, or at least very much reduced, by the use of a windshield. You can construct one of these out of two pieces of white cardboard, hinged together with adhesive tape. You place this shield close to the subject in order to protect it against the wind, but unfortunately the direction of wind and sun are quite often the same, and you cannot protect the subject without also throwing it into shadow.

I normally use a different kind of windshield, consisting of two sheets of thin acrylic plastic (approx. 20 x 30cm each), hinged together with clear adhesive tape.

This device works quite well but you should note that the hinge, although made of transparent material, can throw a distinctly visible shadow nevertheless. The sheets can also pick up reflections directly from the sun and concentrate them on the subject—this needs to be watched.

Additionally, you could carry a second windshield of white cardboard (its back covered

42 Unless it is to be the photographer's last picture the only way to approach so close to an alligator's eye is by shooting through the armoured glass of a zoo's vivarium. In such a position the available light may need slight reinforcement with flash but the exposure must be based on the existing light level.

43 Taken through a toughened glass window, in an outdoor tiger enclosure, the paws of the animal were sufficiently well lit, even though the rest of his body was too shadowy for good results without the support of fill-in flash.

44 The extreme contrast of oblique sunlight can cause many exposure problems. With colour slides particularly, it is essential to base the exposure *and* this kind of 'selective' composition on areas of the subject that are more or less uniformly lit, excluding significantly large highlights and being prepared to dispense with shadow detail altogether.

45 For available light photography you often have to use high-speed films (In this case, ASA 400) and large apertures (*f*/5.6). With higher magnifications (0.8 X) taking pictures may easily turn into a major artistic feat. But it is often worthwhile as being the only way to preserve the feeling or mood of a subject. Other data: 1/60 sec, 100mm macro lens, camera with angle viewfinder, hand-held windshield.

Of current black and white and colour film using traditional emulsions, those with a rated speed of ASA 400/27 DIN (400/27°ISO) are probably the best all-round choice for such work. Faster materials of this kind are, in my opinion, limited in usefulness by their pronounced grain. Film using tabular grain technology (eg. Kodacolor 1000 VR), however, can offer more than twice this speed with no increase in grain becoming apparent. This offers clear advantages in such situations.

Auto exposure and hand metering

Because I want to keep complete control of exposure effects I would not dream of using the automatic exposure system of my 35mm camera in, for example, landscape photography. But I usually do so in close-up work without any problems whatever.

This seems to work because in close-up subjects the typical distribution of grey values comes closer to the theoretical distribution on which the automatic exposure systems are based. Although there are, of course, exceptions, like branches photographed against the sky, or white blossom filling the entire frame, the kind of close-

with crumpled aluminium foil). This comes in quite handy for filling in shadows with reflected light. Although its use, strictly speaking, destroys the truthfulness of the available light situation, you might need it in very strong and hard light to reduce subject contrast, especially when working with colour films.

But whatever you do with these contraptions, setting them up requires a few moments and their use is therefore mainly restricted to immobile subjects. If you want to photograph small animals in available light, you will have to rely on fast film.

up subject generally preferred does not include the sky, which is responsible for a lot of exposure problems.

If you do not have a camera with TTL metering, you will have to use a separate hand-held exposure meter.

Separate exposure meters for use in close-up work should preferably have a very small angle of view (perhaps 1°) and a finder that shows exactly which part of the subject is being measured.

Incident light meters are not very suitable for close-up work because the subjects usually are so small that it is impossible to position the meter accurately without moving or even destroying the subject.

Interesting possibilities are offered by fibre optics, which can be attached to the exposure meters of some manufacturers. Some of them can be connected to the eyepiece of 35mm cameras, while others are used for measurement on the viewing screen, so that you can turn all medium format or even view cameras into TTL metering systems.

In special cases (for example, photographs taken by fluorescent illumination) this may be of interest to you, even if your camera does have a TTL metering device, because these systems can measure extremely low light, which may be far below the limits of the built-in exposure meter.

If you do not have a TTL meter the problem of obtaining exposure readings for close-up varies considerably with the situation. The main difficulty is usually that the camera lens, being close to the subject, does not allow sufficient working space for the meter to be introduced. A spot reading meter can more easily be used, from a position close to the lens, but ordinary meters cannot. With daylight or other continuous light sources, however, that give a very generalised illumination, it is sometimes possible to obtain incident light readings or reflected readings from an equivalent area alongside the subject. Readings can be taken on a standard 18 per cent reflecting grey card held alongside the subject, or the incident meter may be suitably positioned for the same purpose.

46 If the difference between an available light photograph and the same subject taken with flash is only slight, it is surely not worthwhile using additional light. But situations like the one shown here cannot be contrived and cannot be artificially lit. Magn. 0.9 X, 100mm macro lens, *f*/4, 1/160 sec, hand-held camera, winder (this was the only properly focused one of 7 negatives, I must admit!)

47, 48 The most important aid to taking these two pictures is the windshield. But the positioning must be done with care so that neither it, nor its shadow can be seen in the picture. It can be quite difficult to secure the shield adequately in a strong wind. The easiest way is to have someone hold it in position for you. If you have to do this yourself you may need stones or strings to anchor it safely. But it is worth the trouble because wind is the main reason for out-of-focus pictures.
47: Magn. 0.6 X, 48: 0.3 X, other data: 100mm macro-lens, *f*/16 and *f*/8, 1/125 sec, and 1/60 sec, hand-held camera.

11 CONTINUOUS ARTIFICIAL LIGHT

If you judge by the effect achieved, there does not need to be a difference between available light and artificial lighting, because you can obviously copy the effects of available light by means of artificial light sources. But this is not usually the idea behind the use of artificial light. With artificial lighting you can exceed the limitations of available light and create an ambiance which, on the one hand, suits your ideas and, on the other, the requirements of the subject matter.

In doing so, you can work along the same lines that guide you in general photography, although you will meet with possibilities and limitations that are peculiar to close-up photography. I will have to assume that you know the basics of lighting in general photography, so that we can confine our discussion to the special considerations of close-up work.

Diffused and directional light
A bulb placed behind a matt screen, or the lamphouse of an enlarger designed for colour photography produces diffused light, which is sometimes called scattered or random light, while a bulb placed behind a collecting lens or in a reflector provides us with directional (focused or concentrated) light. (See Fig. 9)

Diffused light creates illumination that is soft and has weak shadows, while sufficiently directional light results in very sharp and strong shadows. The main properties, advantages and disadvantages of these kinds of lighting are described in the following table.

Fig 9 Diffused and direct light. A light source placed behind a matt screen gives diffused or random light. Where the lamp is fitted with a reflector, the light is more direct. A lens positioned in the light beam collects and concentrates the light on the subject.

11.1 Diffused and directional lighting

Diffused light	Directional light
Source: matt screen, light-box, completely overcast sky	Bulb in reflector, with lens, strong direct sunlight
Shadows: soft, weak or none at all, low contrast	Strong, well defined, high contrast
Surface: small variations in surface structure may be entirely invisible, no highlights	Structure clearly shown (strongest effect with light from oblique angle) specular reflections
Colour: colour rendering very good	Colour rendering may be poor due to reflections from coloured surfaces, highlights and over-strong contrasts

So far, this is entirely straightforward and not very different from conditions in general photography. Nevertheless, some problems arise which are peculiar to close-up photography.

Size of the light source
Household lamps of all kinds and descriptions as well as lamps designed for general photography should be very much a last resort as a light source for close-up work. The first and most important reason for this is simply that:

What may pass as a light source producing reasonably direct illumination in general photography, will act as a source of diffused light in close-up photography. Because the light source is much larger than the subject matter the light rays 'creep' all around it. (Fig. 10)

Another consequence of the size of the light source is shown in the diagram. Only a fraction of the light that it produces actually falls on the subject, so that even a strong light (measured by

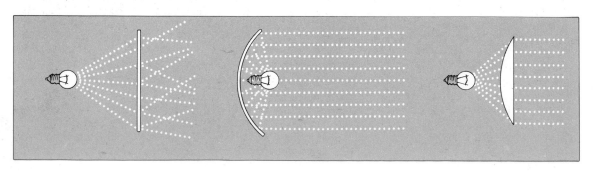

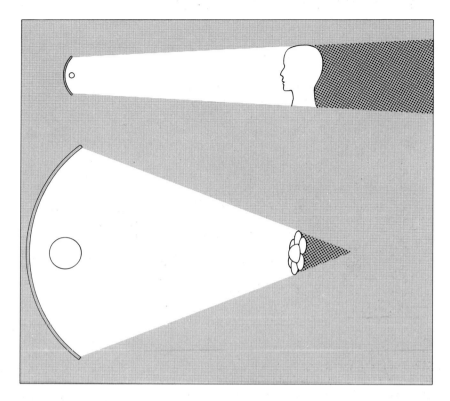

Fig 10 In close-up work, due to the size of the average light source in relation to the subject, the character of the lighting varies with the lamp distance. The same lamp gives directional light with a large shadow area when placed far from the subject but diffused illumination with small cast shadows when positioned nearby.

the standards of general photography) may be very weak for close-up work. Very small low-wattage lamps specially designed for close-up photography can throw much more light on your subject than large and powerful floods, which you would have to place at a considerable range from your subject in order to obtain reasonably directional light.

The third argument against the use of all-purpose lamps in close-up work is the heat they produce. If you do not place them at some distance, the object can suffer from this, especially living things.

Fibre optics for illumination

The preceding remarks give us our clues for a description of the best possible light source for close-up work. It should be as small as possible and as cool as possible, but with a very high output.

Actually, there is only one kind of light source that fits all these conditions perfectly: a cold-light projector fitted with fibre optics. A typical one of these models features three adjustable gooseneck fibre optic light pipes, or channels, to which can be attached various filters and lenses (for even more directional light).

The light emitted by fibre optics remains sufficiently cold for them to be placed very close to the subject and the 150 watt halogen lamp of the projector produces enough light to allow very short exposure times even with high magnifications. Additionally, the manufacturer of the equipment possess offers other fibre optic attachments for the projector, like ring lights, transillumination boxes (including dark field lighting), and others, so that it really is the most versatile and efficient light source for close-up photography.

The cost factor: mini-spots and microscope lamps

Like many good things, it has a serious drawback. The equipment just described costs as much as a very good 35mm SLR camera. Other manufacturers offer cheaper light sources of this kind, but they do not necessarily have the same range of accessories, or they may be weaker or hotter. Therefore you should test these points carefully, before investing in this type of light source.

In this respect you may be interested in my experience. When starting with close-up photography, I bought various mini-spots, then added a microscope lamp (which was quite expensive also). But the equipment always showed its

49 Taken in a hothouse, this subject was simply illuminated with a gooseneck lamp borrowed from a typewriter desk. Magn. 0.8 X, 100mm macro lens, camera with focusing rail on tripod, 1/125 sec, f/8.

50 This photograph was taken in a hothouse by the available tungsten light which was very diffused. Compare this with the strong, directional light in the next illustration! Magn. 0.8 X, f/5.6, 100mm macro lens, 1/125 sec, camera with focusing rail on tripod.

limitations too soon, so that I ended up by buying a cold-light projector as well. It would have been much cheaper (and better for my work) if I had done so immediately. If you do a great amount of close-up work, or intend doing so, it may be better to buy the more expensive equipment straight away and add it to the cost of all the other gadgets in which you have previously invested. Apart from this, cold-light projectors have a good re-sale value and mini-spots do not.

This advice on the wisest way to spend money has to be qualified, of course, by the availability of money! If your funds are limited or your close-up work is only occasional and does not justify such expenditure, you will have to work with the low cost equipment already mentioned. Nevertheless, to understand the principle behind the ideal choice can help you with selecting, adapting or improvising equipment of the humbler sort for the purpose you have in mind.

Mini-spots and microscope lamps are both relatively inexpensive. Apart from the heat output, mini-spots with 12 or 16 volt halogen bulbs will work quite well although some of them produce very uneven lightcones. This does not matter much with very small subjects because you can

usually find a part with relatively even illumination which covers your field of view. But they are ruled out for everything bigger than, say, a thumbnail.

The heat output of these lamps can be reduced by special heat-absorbing filters, which can be ordered or bought from suppliers of scientific hardware. Unfortunately these filters are quite expensive in the relatively large areas needed for mini-spots.

If you should happen to own a microscope or stereo microscope with detachable light source (of the kind with 6 or 12 volt halogen lamp, iris diaphragm, and collector lens), you have the second best choice for close-up lighting equipment. These lamps generate a powerful beam of directional light and are at the same time very small, allowing you to use inexpensive, standardised heat-absorbing filters. However, heat reduction is often superfluous, because their intensity can usually be freely selected. Consequently, you can make all your preparations under low and therefore cool light, and use the maximum output for the actual exposure only.

Mirrors

If all of this exceeds your budget, or if you take close-ups only infrequently, you should at least be able to acquire two small shaving mirrors (one side flat, one side concave) and one or two pieces of cardboard, covered with crumpled aluminium foil. Used in conjunction with one household (or studio) lamp, or even available light this equipment is amazingly versatile.

Fig 11 shows a set-up where an ordinary household (or studio) lamp is used as a secondary light source, while a shaving mirror with its curved side facing the subject collects the light and works as the main light source. This works because the light emitted by the lamp is collected and concentrated by the mirror. If necessary, you can use more than one shaving mirror to build up more complicated arrangements.

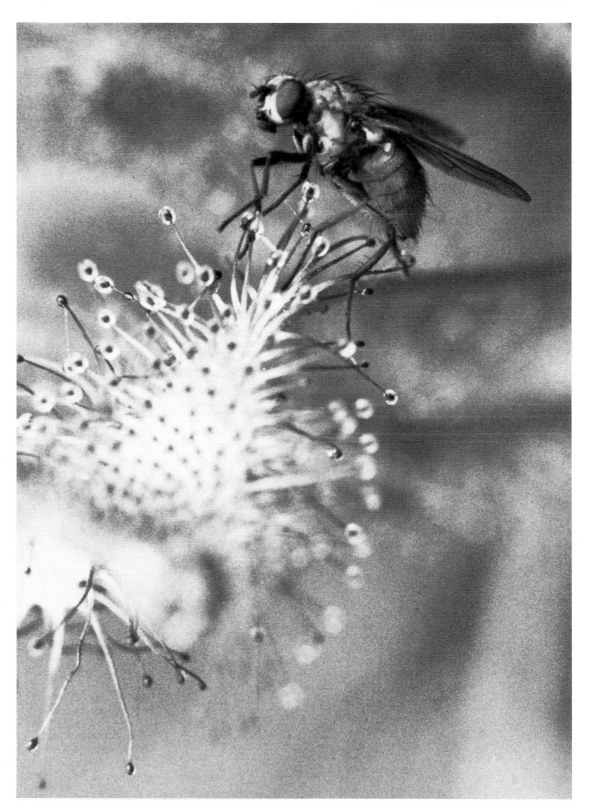

51 The rather expressive lighting of this plant was made possible with fibre optics, which allow you to build up your lighting with extreme flexibility. Magn. 0.3 X, *f*/22, 1 sec, 100mm macro lens.

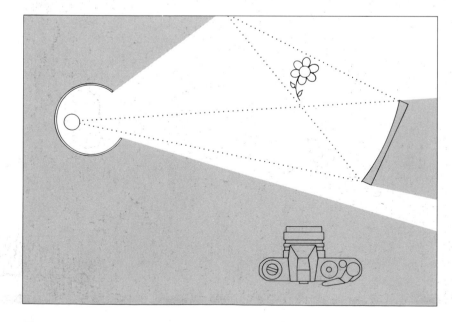

Fig 11 A household or studio lamp can provide relatively diffused general lighting while rays from this concentrated by the curved side of a shaving mirror can provide the main, directional light on the subject.

52 Dramatic and well-balanced lighting produced by the simplest means; the lighting is a mixture of daylight (window), a mini-spot placed at approx. 2m distance and a shaving mirror (flat side). Magn. 0.4 X, *f*/8, 1/15 sec, 50mm macro lens, camera on tripod.

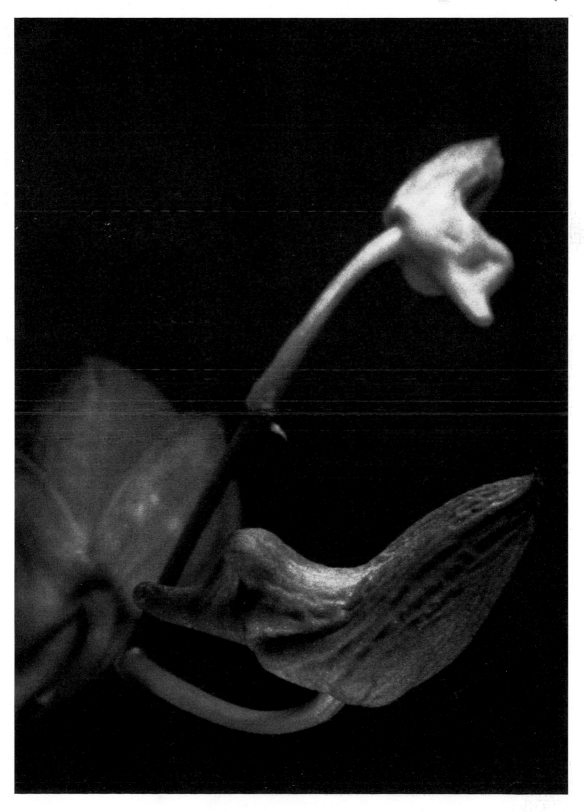

12 SPECIAL LIGHTING EFFECTS

Shadowless lighting

Shadowless lighting is rarely desirable for creative photography because it does not show surface structure and is therefore flat and lifeless. On the other hand, it is the only kind of lighting which reveals all the details of subjects because nothing is obscured by shadows. Various kinds of shadowless lighting suit different applications.

Direct coaxial light

Theoretically, the best possible light source for shadowless lighting would be the lens itself. In photomicrography this situation can indeed be realised with metal objectives and epicondensors. Comparable lenses for close-up photography do not exist, but there is a solution that is almost as good.

Fig 12 shows an arrangement where a semi-reflecting beam splitter has been placed in front of the close-up lens. The beam splitter mirror reflects the light from a spotlight (microscope lamp with collector lens) on to the subject, covering the same field as the lens. Due to the particular properties of the mirror, the view and performance of the lens are unimpaired.

This kind of illumination, using a focused coaxial light source, is very different from the diffused light normally used to produce shadowless lighting. The reason for this is that it shows minute changes in the surface reflectivity of the subject, stressing highlights and suppressing less reflective areas. So it can be the exception to the generalised statement made above: coaxial focused light can be shadowless and nevertheless show the surface structure of subjects. How this differs from normal shadowless lighting is explained by comparison with the ringlight in Fig 13.

One manufacturer who offers a lighting system of this kind is Olympus, whose mirror boxes of various sizes (called PM-EL) from part of a complete macro photo system. These mirror housings can be bought separately and—although they are meant for specific macro lenses—can be modified for lenses of other manufacturers. (Modifications would have to be done either by you or by a camera repair specialist!) It is also possible to buy beam splitter mirrors separately at scientific hardware dealers and some view camera manufacturers, so that you could construct your own lighting system from scratch.

Diffused coaxial light—ringlights

Some manufacturers offer ringlights built into special close-up lenses (usually lenses for special medical applications, like dental photography etc), others produce them as accessories, which can be used with virtually all lenses.

Some of these ringlights work with fibre optics, light tubes or small bulbs and provide continuous light only. Others are flash units with only one or two bulbs for continuous light, serving as pilot lamps.

But whatever the construction, the principle

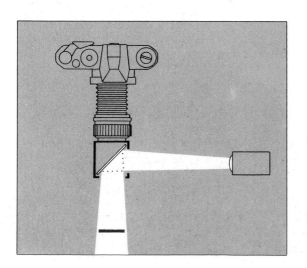

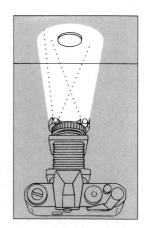

Fig 12 Lighting on a common axis with the camera lens can be provided by a beamsplitter (semi-reflecting mirror) placed between the lens and subject and at 45° to a microscope lamp or similar small concentrated light source. Co-axial illumination provides direct lighting that is able to penetrate deep recesses and structures.

Fig 13 Ringlights are light sources mounted radially around the lens. They provide all-round diffuse frontal illumination which is completely even.

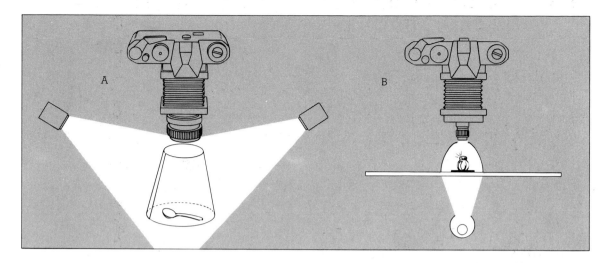

remains the same. The ringlight is clamped or screwed on to the lens (see illustration), thus providing entirely even illumination without shadows or highlights over the entire field of view.

Light tents

If you do not have a ringlight, you can improvise excellent shadowless lighting in various ways. For relatively small magnifications (less than life size), you can use a sheet of white paper rolled into a conical tube. This tube is then placed over the subject as is shown in Fig 14A. Two lamps are sufficient to provide an entirely even light when the tube is constructed out of ordinary writing paper, three or perhaps even four lamps would be necessary for complete evenness with tracing paper, because it is much more transparent. For the same reason, however, tracing paper requires *less* powerful illumination, not more, so the lamps could be further diffused or moved away slightly.

Even if you use only one lamp, the illumination is fairly diffused with only a trace of shadow— which often may be much better than completely shadowless light.

Reflectors for small subjects

For great degrees of magnification (and consequently small subjects), you have to choose a different arrangement, as in Fig 14B. The pièce de résistance here is an eggshell sawn in half and provided with a small hole on top for the lens (of the Luminar or Photar type). In order not to make a mess of this, you should obviously use a really hard-boiled egg, a very fine saw and a bit of patience. It helps if you cover the eggshell with a

Fig 14 Shadowless lighting for small scale subjects. **A** Set-up for low magnifications. A paper cone is placed over the subject and an opening at the top is left for the camera lens. Lights shone on the outside provide diffuse light internally. **B** High magnifications of small subjects. The subject is positioned on a glass plate and covered by the section of an eggshell. A lamp, positioned below the subject directs light through the glass. This is reflected on to the subject via the inside surface of the shell. A small hole cut in the top of the eggshell is large enough to admit a view to the macro camera lens, of the Photar or Luminar type. The result is all-round diffuse lighting. The principle is similar to that employed by Lieberkühn reflectors.

thin coating of two component adhesive or similar substance prior to sawing it in half because this adds stability to the whole thing.

An eggshell prepared in this way is an almost perfect parabolic reflector and therefore produces completely even illumination.

The object to be photographed is placed on a circle of dark material such as black cardboard as shown in the illustration. This circle should be larger than the light source below it, or at least large enough to cover the entire field of view, so that in this way only the light reflected by the eggshell and then off the subject matter can reach the lens.

There is, of course, a professional way to produce this kind of lighting. This is with the aid of a so-called Lieberkühn reflector. These are nothing but parabolic reflectors which are attached to the front of the lens. They work in the same way and need the same set-up as the eggshell arrangement described here. Their main advantage over the home-made eggshell reflectors is that they work over a wider range of magnifications and are easier to set up and use.

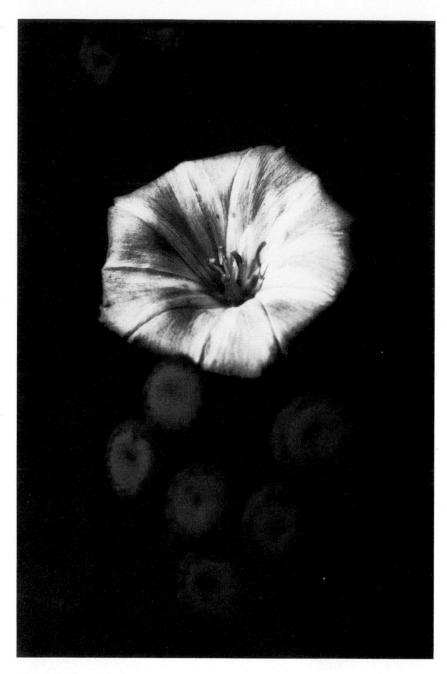

53 One special lighting method that is much easier to apply in close-up work than normal photography is to shade off part of the subject! This 'cheat' is particularly valuable in creative work where all methods serve the end result. With black-and-white pictures it is easy to make final adjustments to tone relationships in printing — but it helps to have the right basis already present in the negative.

Monochromatic light

If you want to try your luck with very high magnifications (20 x or more) and do not have lenses specially designed for this purpose, you will run into serious difficulties because of chromatic aberration. The differing wavelengths of light (for example red or green light) that make up a conventional light source cannot all be focused on the film plane simultaneously. The result is a picture which is never properly sharp.

You can remedy this by using monochromatic light, ie. working with only one wavelength. For this you have to place a strong green (or red or blue) filter in front of your light source. The problem here is that you have to focus with the filter already in place to obtain a sharp picture and this, too, may prove difficult because monochromatic filters absorb a considerable amount of light, making it difficult to see anything at all.

Obviously, this works only for black and white pictures and red filters cannot be used in combination with orthochromatic films.

13 TRANSILLUMINATION

The word transillumination is used to describe all those lighting situations where the light travels through the subject to the lens instead of being reflected from it. The subject in this case must be completely or at least partially transparent. It is an interesting kind of lighting and, in my opinion, it is very worthwhile to look for, or even create, subjects which can be photographed by transillumination.

Available light transillumination

Directional backlight, that is, with the sun shining into your lens, is not practicable for close-up photography because the light is so strong that it destroys all detail. It would work only with a fairly overcast sky. Even then, it would be better to use off-axis light, meaning that the sun is not in your field of view.

If, at the same time, you have a comparatively dark background, you have 'dark-field' illumination (see below) which will clearly reveal all fine surface structures in your subject matter. Hair, beards and similar details, which are scarcely visible in incident light, will stand out as a halo around the silhouette of your subject.

Determining the exposure for this kind of shot may prove a bit tricky, if you want to show detail both in the halo and in the subject itself, because contrast will be so great. Unfortunately the relevant areas are usually so small that spot measurement is impossible. Rather, you should take an overall reading and then bracket your exposures.

Transillumination with diffused light

Generally speaking the differences between diffused and directional light in transillumination are similar to those which apply with incident light. Diffused light reduces contrast and tends to swallow up very fine details. If you do your own enlargements you will know this phenomenon quite well; condenser enlargers give strong contrast and reveal all scratches and dust specks, while diffused-light enlargers give lower contrast and hide many blemishes.

This is why slide-copying and negative reproduction are usually done with diffused rather than focused illumination. Subjects suspended in transparent or translucent plastics or in amber, crystals, thin sections of semi-precious stones,

multicoloured liquids, air bubbles (in liquids) and similar subjects may be photographed by diffused transillumination.

You may already have a light source suitable for this kind of lighting. You can use a slide-viewer provided that you can remove the lens. Ordinary slide sorters may do as well, although some of them have a very weak light output.

The best light source for this purpose is a slide duplicator, which usually has continuous as well as flash illumination; alternatively, a colour head for an enlarger provided that you can turn it upside down. (You can remove the colour heads of most enlargers and turn them upside down. But you should use it in this position only if the manufacturer specifically states that you can do so, because otherwise the halogen lamp and cooling system might easily be damaged if they are not meant to be used this way!)

Colour heads for enlargers are probably the most versatile light sources for transillumination, because they feature a set of filters which allow interesting variations in close-up photography.

If you do not have any of the equipment mentioned above, you can simply use an opal or frosted bulb in conjunction with a matt screen (made of glass or acrylic, depending on the heat emitted by your light source).

Transillumination with directional light

Transillumination with directional light is a bit more difficult to organise. Some manufacturers offer professional equipment suitable for this kind of lighting, but it is usually quite expensive. This does not apply if you already own a cold-light projector with fibre optics as described in the previous chapter, where optional accessories for all kinds of transillumination are available at a reasonable price.

If you do not shy away from a bit of do-it-yourself work, you can easily convert the lamphouse of an old black-and-white enlarger for your purposes. It has to be turned upside down. (There is no problem here, as long as you do not obstruct the ventilation holes.) You can then place the object to be photographed either directly on the surface of the condenser lens or in the negative carrier. A dimmer for the regulation of the light output would be useful because the light would be too strong for most applications.

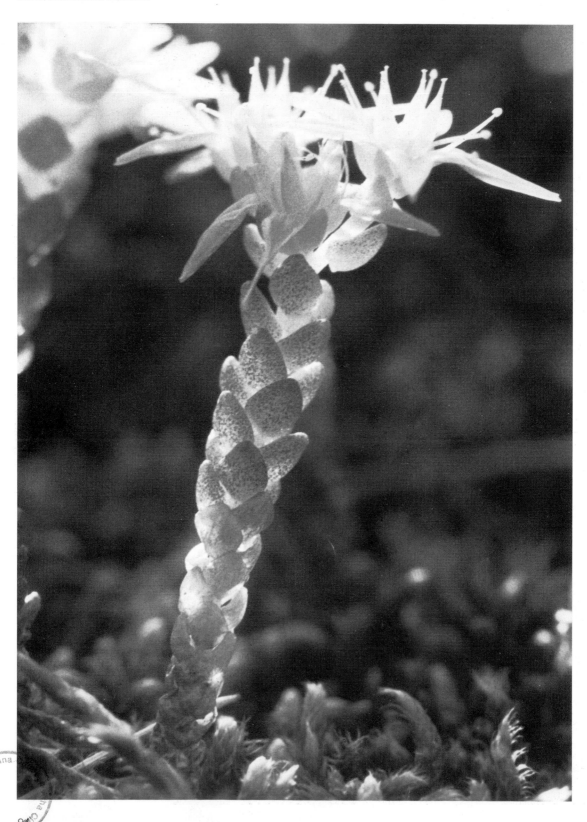

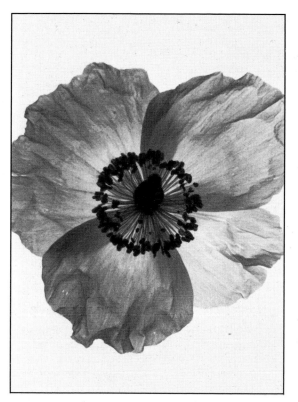

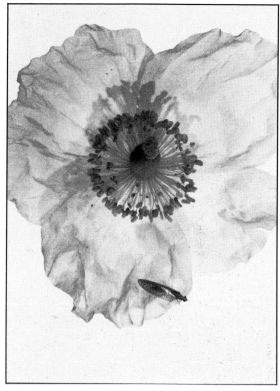

54 In most cases a dark background enhances the effect of available light transillumination. In this photograph the stem of the very small and translucent plant almost seems to glow (Sedum acre L.) Magn. 1 X, *f*16, 1/250 sec, 100mm macro lens, angle viewfinder, hand-held, windshield.

55 A slide sorter with a white matt screen served as the light source for this photograph, which was taken entirely by transillumination. (note the black stamen). Magn. 0.3 X, *f*/22, 2 sec, 100mm macro lens on bellows and focusing rail, camera with winder mounted on copying stand.

56 The same as the previous illustration, but with a mixture of transillumination and incident light (provided by fibre optics). Note that the plant itself throws no visible shadow, but shadows of stamen etc are distinctly visible. Often this mixed lighting looks better than pure transillumination. Technical details as for Ill. 45 except for exposure time, which was 1 sec. The insect came in through the open window and settled itself on the bloom while I was working. It stayed there for exactly one exposure.

Fig 15 Home constructed arrangement for transillumination. A condenser lens is mounted in the top of a box which also has one end open. The box contains a mirror positioned at 45° to the top surface and open side. The subject is placed on the flat upper surface of the condenser. Light from a mini spot or microscope lamp enters the open end and reaches the subject via the mirror and condenser. A slot at the open end can accommodate filters, matt screen (for diffusion) etc. The box can be constructed from wood and the interior is painted black.

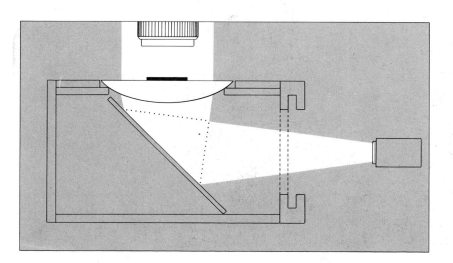

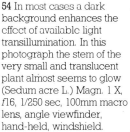

In the absence of an enlarger you can construct the light source yourself, working along the lines shown in Fig 15. But considering that used black and white enlargers come very cheap (a very simple one would do), converting one to your use would be your best bet.

All objects which have only very delicate variations of tone are best photographed by directional light. It is, for example, fascinating to photograph prepared microscope slides by this light. Magnifications from approximately 3 x up to 25 x (or even 30 x) are possible and can result in remarkable photographs.

Although microscope slides are intended for higher magnifications, many of them are also very beautiful taken as general views with lower magnifications—and they are usually quite flat, so you will have no problems with the extremely small depth of field.

If you do not know how to prepare microscope slides yourself you can either buy them ready for viewing or you could try your luck in finding someone who is willing to lend them. There are of course other interesting subjects apart from microscope slides.

Dark-field transillumination

By normal transillumination as described above,

57 Pure abstraction can be created with pieces of clear plastic or film (of the kind used to wrap food) and polarised illumination, as described on page 90. Some very surprising results can occur with this technique, exhibiting a wide range of colours.

the details of the subjects are shown in various shades of grey, graded to black, in front of a white background. The grey values depend on the translucency of the object.

In dark-field transillumination conditions are reversed. The background is entirely black and the subject matter seems to emit light. If you look at Fig 16, you can see how this is achieved. The lighting is so arranged that no light rays reach the lens as long as the object stage is empty. But if you place something there, it scatters and diffuses the light according to its structure and degrees of translucency. Thus it appears as a luminous object in the field of view.

The diagram shows how a light source of this kind should be constructed. The easiest method is to use the appropriate accessory—a cold-light projector with fibre optics. But you can just as well improvise a construction made of a sheet of glass and black cardboard. There are a few points which should be taken into account:

The background should be really black. The

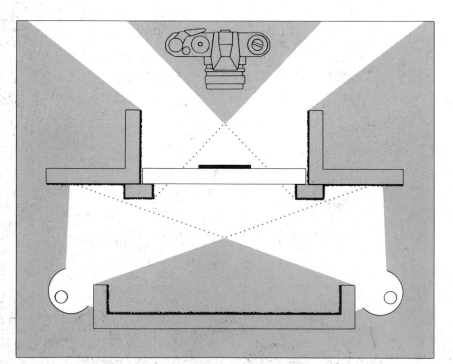

Fig 16 Set up for dark-field transillumination. The subject rests on a glass plate, with the camera positioned immediately overhead. Below the glass plate is a black background separated from it by sufficient space to allow lights to be introduced to illuminate the subject from beneath. These lamps are outside the field of view of the camera lens. Light shields or baffles either side of, or if necessary, around, the subject and around the background, prevent any light from reaching the subject or the camera lens other than directly from the lamps. This construction can be made from black-painted wood or cardboard.

easiest way to achieve this is to shape it like a tray, so that its black surface lies in the shadow of its borders. A similar thing applies to the subject matter, which should be shielded against stray light, for example by simply placing a conveniently shaped lens-shade over it.

With many subjects, exposure determination may be a bit difficult due to the prevailing black background and its strong contrast with the luminous areas. If your camera is equipped with a spot measuring exposure meter you can try to measure a part of the subject matter which appears to be of a middle grey value. But I think that another method is preferable. As a reference, you can either use a grey scale or a negative that you have exposed and developed to a middle grey. Position it on the glass in place of the subject matter and measure the exposure required. As long as you do not change your set-up you can use this exposure for all kinds of subjects.

Dark-field illumination is perfect for all very delicate subjects. Very small changes in density which you might not notice at all in normal transillumination will be clearly revealed. Very small structures or internal details which are close to—

58 This polarised light picture was built up from strips of transparent adhesive tape. (The jagged edges result from tearing the tape off the reel, using the toothed cutter.) The subject is, of course, greatly magnified. The appeal of the picture lies not simply in the layered effect but in the fact that the closely related cool blues and greens are punctured here and there by small areas of 'hot' contrasting colours.

59 These bits of clear adhesive tape and (transparent) sandwich wrapping develop an interesting structure when viewed in dark-field lighting. Even irregularities in the glue, which are not visible in transillumination, become apparent. As a matter of fact, this kind of subject would become almost entirely invisible in transillumination. It is the same kind of material that I use for my work with polarised light (compare with colour ill **57**). Magn. 1.3 X, 50mm macro lens on bellows, focusing rail. *f*/16, 4 sec, camera with angle viewfinder on copying stand.

or under certain conditions even below—the visibility threshold in other kinds of lighting can be made visible. The set of illustrations shows the differences between incident light, transillumination and dark-field lighting with the same subject matter.

Polarised light

Polarised transillumination allows you to explore a whole new area of subjects and special effects.

There is no need here to go into the physics of polarised light. Suffice it to say that some materials, like certain crystals and many clear plastics, have the property of being what is called double-refracting, or anisotropic. In practice, this means that such substances, although generally colourless or at least of an uninteresting uniform colour, show an abundance of colours and hues when viewed or photographed in polarised light.

This effect is used in scientific photography to explore a variety of problems. Here we are concerned only with the aesthetic side of the phenomenon.

First I would like to explain the set-up necessary for this kind of photography. Fig 17 shows the principles of the construction. You need a light-box, slide-sorter, slide-copier or a similar light source for transillumination, over which you can place a polarising filter (the cel type will do because highest optical precision is not necessary here). Between this filter and the subject

60 A very common use of transillumination is for the removal or prevention of strong shadows. These sunflower seeds were placed on a slide sorter and illuminated additionally with incident light (fibre optics). Note that no two of them are alike! Magn. 0.9 X, *f*/22, 1/2 sec, 50mm macro lens on bellows and focusing rail, camera with angled viewfinder and winder on copying stand.

selected enough room should be left for some additional filters, which I will discuss later.

It would be best to use a sheet of glass to support your chosen subject or, if you prefer to mount your specimens in slide-frames, a piece of cardboard with a hole in it over which you can position the slide.

It is equally possible to use a bellows unit with a slide copier attachment, but then you would have to remove the matt screen which is mounted in front of the unit. Also, do not forget, you have to place the second polarising filter in front of the lens! Not all slide copying attachments can accommodate filters and even when this is possible you may run into difficulties, because polarising filters must be rotatable and in some cases have no front thread.

In my opinion the easiest solution is to mount the camera on a copying stand and to construct the filter set and object stage from black cardboard and two-component adhesive. I used such a contraption myself for a few years but have now built one out of wood and metal because more recently I have been specialising in this kind of close-up work.

But to return to the filters. If you simply place your subject between two polarising filters, you may or may not see any interesting changes in colour. Transparent boxes (the kind made for storing filters) and other things made from moulded plastics will work, while many crystals and substances like the clear film used for food wrappings show only various shades of grey or very faded and weak hues.

In order to bring out these colours you need additional filters, which have to be placed between the pola filter foil and the object stage. These filters are not available commercially, so you have to make them yourself. They consist of the clear plastic sheets used in model construction and graphic design. This material can be purchased cheaply in large hobby shops or suppliers of graphic materials.

These filters strengthen or change the colours of your subject, depending on the thickness, the number of filters used and their position in relation to the polarising axis. Therefore, like the polarising filters, these filters too should be rotatable.

The illustrations show some easily obtainable materials, photographed with the arrangement described here as well as a more sophisticated subject in order to give you an idea of the wide field at your disposal.

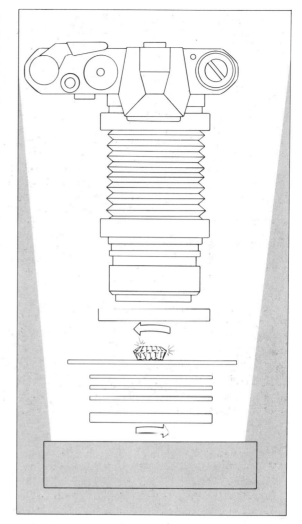

Fig 17 Set up for photography by polarised transillumination. The light source is a slide sorter, slide copier or lightbox. Over this you place a polarising filter and between this and the glass plate that supports the subject there should be space for a variable number of other filters. All the filters below the subject can be non-optical and the pola filter must be sufficiently free to be rotated. Above the subject is the camera, fitted with another pola filter, also rotatable. The unit can be constructed from wood or cardboard and painted black to minimise reflections.

14 FLASH

If everybody owned a 35mm SLR camera with built-in flash metering much of this chapter would be superfluous.

Such cameras measure the amount of flash light reaching the film and control the output of the flash unit accordingly. Due to the internal method of measurement all factors influencing the exposure, like lens extension, f-stop and filters are automatically taken into account. Within given, very generous limits, with these cameras you can simply point the flash at your subject and fire away, regardless of the magnification used. You can even fire the flash straight into the lens as long as you use a suitable matt screen. So the automatic flash exposure works even with transillumination.

This kind of camera and flash unit are practically foolproof in use and if you intend to do a lot of close-up work with flash you should consider buying one—especially if you are working with small animals or other mobile subjects.

Nevertheless, many people either want to, or must, make do with less sophisticated equipment.

Illuminating with flash

While strong black shadows are a common problem with flash in general photography, the reverse may be the case with close-ups, for reasons which I explained in the chapter on continuous light (Chap 11). The light source—in this case the reflector of the flash unit—may be much larger than the subject, which results in very soft lighting.

While this is usually quite sufficient for colour photography, the contrasts may be too low for satisfying black and white pictures. There is not much that you can do to help matters but if your flash unit has a telephoto attachment or similar, you should use it for close-up, even though it may look a bit ridiculous. These attachments contain fresnel lenses which serve to collect the light rays and concentrate them in a narrower angle. Although this solution is not perfect, it is the closest thing to focused incident light that you can achieve with flash.

Another problem, especially strong when you use one of these tele-accessories, is aiming the flash unit. The type of flash unit that must be attached to the hot shoe of the camera is entirely useless. Its light either does not hit the subject at all or is partly obscured by bellows, extension

rings or whatever you have attached to your camera. You must use only the kind of flash unit that you can position anywhere close to the camera, either on special brackets for hand held photography or even with separate tripods in stationary work.

Some units come with a power grip (otherwise known as hammerhead units) to which the bracket for attaching the camera is fixed. They can only be used for close-up work if the height of the reflector can be adjusted in relation to the lens axis and if it can also be rotated. Some manufacturers offer special mounting brackets for this kind of adjustment.

These considerations are much more important than the power of the flash unit. A great light output signified by a high guide number is not necessary for most kinds of close-up work because the flash unit is usually placed very close to the subject.

Computer flash

Computerised flash units are designed to adjust exposure by flash duration according to the subject range and with a pre-determined aperture setting. They are not suitable for close-up work (except when used in the manual mode) for two reasons. First, the built-in sensor cannot be pointed accurately at the subject due to its relatively wide angle of measurement and the lack of an aiming device. Secondly, the light output of the unit exceeds the capacity of the measuring device at distances shorter than those quoted by the manufacturer. Nevertheless, some of the more sophisticated flash units feature external sensors which can be adapted for close-up work, or you can buy a fibre optic accessory which is connected to the built-in sensor and can be aimed directly at the subject matter.

Although these accessories work quite well, you still have to calculate for aperture corrections which depend on the magnification used. This is relatively easy to do with macro lenses, which

61 The black backgrounds created by flash are not generally desirable. But, especially in black-and-white work, they sometimes help to simplify and strengthen the composition, as in the case of this picture, which consists almost entirely of black, dark grey and almost white tonal values. Magn. 0.5 X, f/16, 1/60 sec, 100mm macro lens, flash mounted on extension bracket, hand-held camera.

have the relevant magnifications engraved on their barrels. But it becomes more complicated with bellows or extension rings, because with them you have to determine the magnification first.

So this kind of computerised flash is a real advantage and allows you to work quickly only if you restrict yourself to a few 'standard' magnifications. Then you can memorise the necessary aperture corrections easily, so that you are always prepared to shoot without first referring to tables or calculations.

Actually, the use of computerised flash is closely related to flash in the manual mode (explained below). It simply offers an additional safety margin for subjects of very unusual grey values.

Using manual flash

For the purpose of the following comments, the term 'manual flash' of course includes computerised automatic flash units used in the manual mode.

If you own a 100mm macro lens you may have a

62 You should not believe that flash automatically solves the problem of blurred pictures. The exposure time needed for synchronisation is relatively long (with focal plane shutters) and the flash will arrest the movement only if the level of available light is very low compared with the intensity of the flash. Owing to a very strong wind this picture needed a wind shield, otherwise the movement of the plant would have shown. Exposure without flash would have been approx. 1/15 sec! Magn. 0.4 X, f22, 1/60 sec.

very easy way of shooting close-ups with flash. With some lenses of this type and a flash unit mounted directly beside, or on top of, the camera, you can use the same aperture setting for all magnifications from 0.2 x (1:5) to 1 x (1:1). The f-number you need will be approximately:

Guide number x 1.2

In this range of magnifications the necessary exposure increase and the changes in the distance between subject and flash cancel each other out.

Due to differences in construction between lenses of different brands, which were explained

63 Photographs like this one of mating bugs would probably be very difficult to secure without flash — at least, out of doors. The high magnification, the movement of the subject and that of the hand-held camera allow no other solution. Magn. 1 X, other data as in previous illustrations.

in the first chapter, this may not work exactly for your kind of lens, so a test run is absolutely necessary!

If most of the subjects you are likely to shoot will be in this range of magnifications, you should investigate this simple approach to close-up flash.

If you have to use other lenses (for example, with longer focal lengths for shy animals, or for even higher magnifications) things become a bit more complicated.

The easiest way out is with a flash meter and fibre optic attachment which you could use to measure the correct exposure by attaching it to the viewfinder of your camera. But although I have seen it done, I do not consider this to be very practical because this equipment is so expensive that you could buy a new camera body with built-in flash metering for the same amount of money.

Therefore you are in for some calculations. Many years ago you may have seen a formula like this:

Exposure correction factor = (magnification + 1)²

This kind of formula works only with strictly symmetrical lenses. You should forget it, because most of today's lenses are asymmetrical. If you want to calculate the correct *f*-number with the formula indicated on page 16, you could make your life easier by always using the same distance between flash and subject (for instance 0.5m or 1.0m) which would provide you with a constant factor like this:

$$\frac{\text{Guide number}}{\text{Distance (flash–subject) in metres}} = \textit{f}\text{-number}$$

If this value did not change, you would simply have to correct this *f*-number for the magnification used. You will find the necessary numbers in Table 1.4 (page 16). Unfortunately, this method of keeping the flash–subject range constant works

only in the studio (or at home), where you can mount your flash unit on a separate tripod and the whole set-up is easily controlled. For hand-held outdoor photography you have to take into account varying distances between flash and subject. I could cite a few pages of tables, which show all possible combinations between guide numbers, distances and apertures, but in my view they are more confusing than helpful. I hope that you will find my way more practical.

1 Decide which magnifications you are likely to use. This is probably simpler than you might think, because most people need only a very limited range of magnifications according to the subject matter which interests them most.

Let us, for example, assume that you want to photograph insects in their natural surroundings: on flower heads, leaves, etc. For this you need:

a a magnification of approximately 0.3 x for large insects like butterflies, dragonflies etc.

b a magnification of about 1 x for small insects.

c a magnification of approximately 2 x for details of larger insects and for extremely small ones (although photography with a hand-held camera is out of the question here or at least exceedingly difficult at this magnification).

2 Set up your equipment (including the flash on its brackets) for use with these three magnifications exactly as you would use it outdoors. The method for determining magnification has been explained in Chapter 1. Then measure the distance between the flash reflector and the point where the subject would be. Take a note of these three distances.

3 For these distances, you can now calculate the basic *f*-number, that is, the *f*-number without the necessary correction due to lens extension, with the following formula:

$$\text{Basic } f\text{-number} = \frac{\text{Guide number of flash}}{\sqrt{\text{flash-to-subject distance}}}$$

(Guide number of flash, of course, refers to the value quoted by the manufacturer of the film you want to use, while flash-to-subject distance is the value in meters, which you have measured in the second step.)

Although drawing a square root should be easy in this age of pocket calculators, you can refer to the following table if you don't want to bother:

m	0.7	0.6	0.5	0.45	0.4	0.35	0.3	0.25
√m	0.84	0.77	0.71	0.67	0.63	0.59	0.55	0.5

It should be noted for those in the know that the formula quoted above is not physically exact, but it has been tested for most available flash units of standard construction (meaning flash units with rectangular reflectors and an angle of reflectance covering the field of view of a 35mm lens) and has been found to work quite well.

4 Let us assume that the guide number of your flash unit is 22 (for the film that you want to use) and the flash–subject distance for a magnification of 2 x is 0.35m. According to the formula quoted above, this is:

$$\text{Basic } f\text{-number} = \frac{22}{\sqrt{0.35}} = 37.3 \text{ (approx)}$$

The next available *f*-number is *f*/32, which is close enough. This is the *f*-number you would use without the necessary exposure correction. By referring to Table 1.4 you can now see that for a magnification of 2 x the necessary correction is approximately three *f*-stops, so that you have to take your pictures on an aperture setting of *f*/22.

If the *f*-number arrived at is too small for optimum lens performance at that magnification (Table 1.3, page 16), then for the best possible results you should either choose a weaker flash unit or arrange your equipment so that you obtain a greater flash-to-subject distance.

You will probably remember from our discussion in the first chapter that these exposure correction factors are precise only for strictly symmetrical lenses.

It has been explained there in full, how to calculate the correct values for all lenses, but you will probably also remember that this was quite a cumbersome business.

Because of this my advice is to stop here and do the fine tuning by a test run (with a +1, +½ and −1, −½ *f*-stop below and above the aperture that you calculated according to instructions.) This would also show up possible deviations due to your equipment and would take into account your personal taste or any other requirements.

The advantage of the procedure described above instead of working with tables of the usual

65, 64 A very low level of available light and/or movement of the subject are generally the reason for using flash. But in both these photographs the light was used to create the special atmosphere: flash is not just a quantity of light! Used properly, it can create a mood just as effectively as other kinds of lighting. Magn. for **65**: 0.5 X, for **64**: 0.7 X.

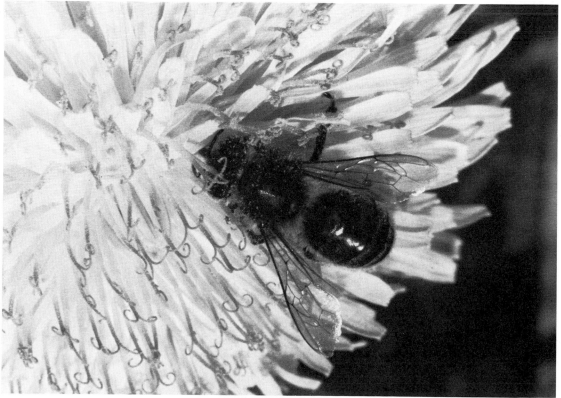

97

kind should be obvious. You obtain three fixed points which can be easily memorised. Starting with these, you could estimate small deviations from your usual routine quite correctly, without referring to a book. Here again, experience makes it easier.

In addition to the process already described, some people would advise you to introduce a further exposure correction which they deem necessary because the light does not fall on the subject head-on, but usually at an angle of approximately 45°. (Some say a half, others, one *f*-stop.) But that applies only to flat subjects. Due to the diffuse character of the flash this does not apply to three-dimensional subjects.

Special tips on flash

In general photography it may be quite a problem to balance the flash light properly with the intensity of the available light. In close-up work this is negligible, because daylight is much too weak compared with the intensity of the flash. But this introduces another problem, which is much worse than in general photography. Even if the subject has been exposed properly, the picture may be quite unsatisfactory, because it has an entirely black background.

There are two ways to solve this difficulty. First, you can greatly increase the flash-to-subject distance which would reduce the fall-off of light to the background. But this is not practical with hand-held shooting, where the flash unit is invariably mounted on, or alongside, the camera.

The other solution would be to use a second flash light, mounted on the other side of the camera. Flash from this unit would have to be much weaker in order not to destroy the effect of the main light and should be pointed beyond the plane of the subject itself, in other words, directly at the background. In order to do this, you have to compute the combined guide number (GN) for both flash units. This is done with the following formula:

$$\text{Combined GN} = \sqrt{(\text{GN flash 1})^2 + (\text{GN flash 2})^2}$$

With this combined guide number you can proceed according to the four steps described above to arrive at the basic aperture for this combination. (This of course works only if both flash units have been mounted at the same distance from the subject.)

If you do it this way, the background will indeed be lighter than with one flash unit only, but the effect is relatively weak due to the very diffused character of the light.

The first method, that is, to increase the flash-to-subject distance, works much better, if it is at all practical.

15 SPECIAL LIGHTING EFFECTS

Up to now I have tried to explain everything concerning lighting that you are likely to need in your work. There are other kinds of light source and lighting effects than those already described. But most of them are too out-of-the-way for general needs or suitable only for very limited special applications. I will list a few of them here without any attempt at completeness in order to give you some ideas for a further expansion of your work.

Working with ultraviolet and infra-red

Some substances (crystals, some inks like eosin, some printing colours, a few kinds of plastic and others) have the property known as fluorescence. When exposed to ultraviolet (UV) radiation, which is of a short wavelength and invisible to the human eye, they respond by emitting (longer wavelength) visible light. They seem to glow.

This effect should be photographed in the following way. The light source should be a special ultraviolet lamp. This need not be made for photographic purposes; a 'sun lamp' used for tanning the body or the test lamp used by stamp collectors works too. Although the latter is very weak, it is suitable for close-up work.

On the lens you need an ultraviolet absorbing filter, because unlike the human eye, the film would respond to UV rays. Thus, you can record the glow-effect of your subject matter. Some manufacturers sell tubes or cans of fluorescent paint, which comes in a variety of colours. This could be used for special effects in table top photography.

Beyond the other end of the visible spectrum we have infra-red (IR) radiation, whose applications are so well-known in general photography. I can restrict myself to describing a special problem with infra-red photography, when used in close-up work.

The infra-red filters for this kind of work block visible light and it is therefore practically impossible to see well enough through them for focusing. In general photography, you do this by focusing without the filter and subsequently correcting the setting according to the infra-red marking on the barrel of the lens. This would be much too inaccurate for close-up work. When working close-up use the strongest light you have and focus on an object with a very strong highlight, like the edge of a razor, which you will be able to see despite the infra-red filter. Remove the object and place the subject to be photographed exactly in the plane of focus.

There are special lenses designed for IR work and free from the focus shift, but they are not readily available to the layman.

Multispectral photography

Multispectral photography is commonly applied in space flight. For example, in earth-resource photography it helps to detect oil and to control crops. It has its military applications as well. It is done with specially designed cameras but can also be improvised with close-up equipment.

Because it reveals information which is not visible to the human eye and because it is only very seldom applied, it might allow you to enter hitherto untrodden territory and may even lead to some scientific discoveries.

The principle is this. A subject is photographed by infra-red radiation (black and white film), in UV, using a black filter, so that only UV rays reach the film (standard black-and-white film) and in visible light (using a normal green filter and standard film). These different films are enlarged in succession on a single sheet of colour material, each time using a different colour filtration. The result is a build-up of separate picture elements dictated by the response of the subject to the different forms of radiation. The actual colours from which the picture is constructed are arbitrary and may be changed at will. For scientific purposes they need to give the clearest differentiation between the elements, but in creative work they could be chosen for purely aesthetic reasons.

There are two problems with this kind of photography. The camera must not be moved between exposures. This is easiest with a camera where you have only to change film backs and filters (and of course you need a sturdy tripod). But it can be done with 35mm equipment as well. You will have to use a bellows or a lens with a separate tripod socket and fasten this to the tripod, so that you can interchange camera bodies without disturbing the whole arrangement.

The second problem is more difficult to solve. If you correct the focusing difference for infra-red work as described above, you will necessarily have to change the magnification slightly. This cannot be helped and has to be corrected in the

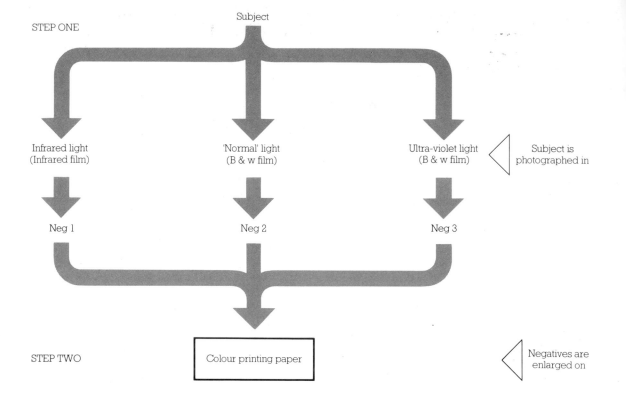

STEP ONE

Subject

Infrared light
(Infrared film)

'Normal' light
(B & w film)

Ultra-violet light
(B & w film)

Subject is
photographed in

Neg 1

Neg 2

Neg 3

STEP TWO

Colour printing paper

Negatives are
enlarged on

Fig 18 The principle of multi-spectral photography. The subject is photographed by three different light sources in three separate exposures on two different film types. After processing, the negatives are enlarged successively on to colour printing paper.

second stage. In the case of large format work, the negative which you have made can be enlarged directly. But you have to correct for the slightly different size of the infra-red one while enlarging it. This must be done very accurately because all three images are to be superimposed on the same sheet of paper. If you start out with 35mm film you have to produce inter-negatives and do this correction when you enlarge infra-red negative on to the intermediate materials.

The latter is probably easier to do because during that stage you are still working with black and white materials.

But, in any case, this photographic process needs a lot of patience and a bit of ingenuity as well, if you want to succeed (which is probably why it is only seldom tried). But if you are interested in difficult technical processes and in darkroom work as well, it might be just the thing for you.

Coloured light

The final item in my treatment of lighting is some-

thing exceedingly simple, which nevertheless may yield interesting and rewarding results.

You simply need two or more light sources, which you can cover with coloured filters. In the case of spotlights and microscope lamps, you can use the special filters sold with these lights, or simple and inexpensive cel filters (colour gels), which are necessary for all other light sources (they should be heat-resistant, otherwise you might set fire to the whole house!)

The best results with coloured lights can be achieved with subjects which have a finely detailed surface. If you place your lamps (each provided with a filter of a different colour) at various angles in relation to the subject matter, the different surfaces of the subject will be shown in various colours and in different mixtures of the original colours.

When working with an arrangement of this kind, you will soon notice that filters of different colours have different densities, so that some of the light sources appear weaker than others. You can leave that as it is, because the effect desired depends on your ideas only. But if you want to remedy it, you can either vary the distances between your lamps and the subject matter, or you could use dimmers in order to equalise the intensity of the various light sources.

16 TRIPODS, STANDS AND RELATED EQUIPMENT

In close-up photography even lenses of the best optical quality will be to no avail if your pictures are blurred due to movement of either the camera (meaning you) or the subject itself.

Image blur and magnification

When shooting close-ups, especially with a hand-held camera, you must always take into account that you not only magnify your subject matter but all kinds of movement as well. The movement of your hands shaking on the morning after the night before, or with buffeting from the wind, though it may not be visible in general photography, can easily ruin a close-up picture.

For example, if the circle of confusion for 35mm photography is 1/30mm, all movements smaller than this which are recorded on the negative or slide will not reduce the apparent sharpness of the picture. The branch of a tree which is reproduced on the film at one hundredth of its real size could move almost 3mm during exposure and still appear quite sharp.

On the other hand a leaf that you want to show life size cannot move for 1/30 of a millimetre without becoming blurred.

Similar conditions apply to camera movement during exposure where the situation is actually made worse by the long extensions commonly used in close-up work. Wherever the axis of movement is, the length of the extension will result in a greater displacement of either the lens or the film plane than in general photography.

With a hand-held camera it is almost an artistic feat to produce a sharp picture life size at 1/60 sec, especially on windy days, and longer exposure times are practically out of the question. (I am not talking here about occasional lucky shots, but about a way to take constantly good pictures!)

Even the use of flash is not insurance for sharp pictures with a hand-held camera, because at higher magnifications a very small alteration in the distance between subject and lens is enough to render it out of focus. Even the involuntary movement you make when depressing the shutter button is enough to change the focusing distance. So you should always carry some camera support or other when doing close-up work.

The 'invisible tripod'

On the other hand, if you have to keep mobile—for example when photographing insects and other moving subjects—the best camera support is none at all. The ideal but (again!) extremely expensive solution to this problem is the so-called 'invisible tripod'.

You may never have heard of this contraption, but it is well known to professional movie camera-men. It is a highly dampened gyroscope, rotating at 15,000 to 20,000 rpm, which is fastened to the camera with an accumulator power pack, carried separately.

When you switch it on it adds so much inertia to your equipment that it actually seems to resist movement actively. This is a very strange feeling when you experience it for the first time, but it results in a stabilisation of your camera, which allows you to use really long exposure times.

When I experimented with the invisible tripod, I could easily hold 1/15 sec at a life size scale without the slightest trace of unsharpness.

The main point is that it nevertheless does not hinder your freedom of movement in the least and you can react quickly to any changes in the subject. Unfortunately, you would probably have to spend more on this equipment than on your camera!

Monopods and tripods

A monopod—a 'one-legged tripod'—is much cheaper but serves a similar purpose. On the one hand it is not as rigid as a tripod, of course, but it does nevertheless give at least vertical stability to your camera. Because you have to watch and manipulate only one leg when changing position you can work much faster than with a tripod. Whenever possible, I prefer to use a monopod rather than a hand-held camera because it is really no slower once you have become used to it. When in a great hurry you can even leave the ball and socket head of your monopod unclamped and it will not impede its performance, if you handle your equipment with a bit of feeling.

A tripod should be rigid, sturdy, vibration-free, lightweight and small. Undoubtedly, there is a contradiction there, but if you restrict yourself to 35mm cameras a suitable model can be found. An all-purpose tripod for larger format cameras as well would have to be much heavier.

You should look for some special features which are indispensable for close-up work. You

must be able to spread its legs out horizontally (which implies a detachable centre column) so that you can take pictures close to the ground, where a majority of close-up subjects are to be found. An alternative would be a tripod with a second tripod screw at the end of one of its legs, but in my experience this does not work as well, because this construction tends to block your access to the camera viewfinder.

Additionally, a tripod used for close-up work should preferably not have a pan-and-tilt head, as opposed to a ball head, because it limits freedom of movement and its handle more often than not is in the way.

Apart from these considerations, the same requirements apply as in general photography.

If you often work close to the ground, a miniature tripod, sometimes called a table tripod, might be your best bet. Most of these are very shaky and therefore unusable, but some manufacturers offer really good ones with strong ball heads. They are more rigid than most tripods with their legs splayed, they can get closer to the ground and are easy to set up in restricted spaces.

Suction stands, tree-screws and other devices

I use two bags for my equipment, a rigid leather holdall and an aluminium case. In both of these I have cut two small holes, one on top of the lid, the other close to the ground on one side. In these holes I have fastened tripod screws (which can be bought separately for a few pence) with two-component glue. Together with a small ball head these serve as emergency tripods when I need one but have left mine at home. I have found them most useful and suggest that you should not hesitate to mar the appearance of your camera bag by making these modifications. However, I admit that having this facility sometimes tends to encourage me even more to leave my tripod at home!

There is a wide variety of clamps, tree-screws (a mount like a stage-screw that attaches to wood), suction stands and other paraphernalia of our trade, but I never could make friends with them. The clamps were either too weak or too small, the tree-screws could be screwed in but not out again, and so on. So I do not recommend them. In my opinion, a well-designed but simple tripod is better than a collection of these mounts.

But if you use them do not forget that the so-called 'tree-screws' are supposed to be used in dead wood only. In this age of air pollution trees have a hard enough life without further mutilation.

Winders and motor-drives as aids

You may be surprised to find a few paragraphs on winders and motor-drives in a chapter on camera supports. But they really do belong here as you will know if you have ever set up a tripod or stand, carefully focused, and then used the film-advance lever. More often than not, this results in a misalignment of the camera or an involuntary change in the focus distance, so that you will have to repeat the performance after winding on to each new frame.

So a winder or motor-wind is always good to have for close-up work, even if you only want to shoot single frames. On the other hand, you should note that the advantage of using a winder may be reduced or even reversed if you fasten your equipment to the support via the tripod socket in the winder. The shifted centre of gravity and the long extension for close-up work may result in a very shaky arrangement. This can only be avoided with a lens or bellows unit which has a tripod socket of its own.

Copy stands and other supports

A tripod is often very inconvenient when doing indoor close-up work. It can, of course, be used for all kinds of table-top photography or still-life, because of the relatively low magnifications used and the more or less horizontal taking axis.

All other work, especially copying and reproduction, is better done with a vertical arrangement of camera and subject matter. Here improvisations with tripods are possible, but the legs will probably be in your way and more often than not throw shadows on your subject matter. It is better to have a good copying stand or a similar support.

Copying stands are not very expensive, as a rule. But they are usually not too good either. A copying stand must be very rigid, and therefore heavy and massive. Good ones are expensive and hard to find, but you could help matters by making some improvements in the form of wooden struts or bars, or by bolting the column of your copying stand to the wall, although the latter arrangement would have to be a permanent installation.

Some manufacturers of enlargers offer acces-

66 I dislike tripods just as much as everybody else, but more often than not, they are vital. With subjects, which are as close to the ground as this, a miniature tripod would be best. Magn. 0.7 X, *f*/16, 1/60 sec, 100mm macro lens, camera with focusing rail and angle viewfinder on miniature tripod, available light.

sories which can turn their products into copying stands, but even reputable brands are often amazingly flimsy. After some unsuccessful attempts to find an adequate arrangement, my final choice was a stand for photomicrography, which I bought secondhand. But there are other possibilities worth exploring.

Some suppliers of scientific hardware offer optical benches, which can be used as vertical or horizontal stands and are less expensive than copying stands of equivalent rigidity.

For magnifications between about 0.5 and 4 x, you should investigate bellows units with integrated stands, which can be bought as accessories for many cameras. They work quite well, especially when they have a friction drive, because rack-and-pinion drives are often not accurate enough for higher magnifications.

Equipment for still higher magnifications, including supports, has already been discussed in Chapter 8.

Supports for the subject

Bellows units with integral (or attachable) close-

67 Subjects much above ground level should be taken with a normal tripod. I think one should, at least, always carry a monopod, which is certainly better than nothing. Magn. 0.5 X, f16, 1/125 sec, 100mm macro lens, camera with winder on monopod, available light, subject fastened to tripod as described in the text.

68 For longer lenses, the tripod becomes indispensable. This plant was taken with a 100-500mm zoom lens which could not have been hand-held. Magn. 0.1 X, f/22, 1/60 sec, camera on tripod.

up stands usually have a grey plate on which you can place the subject. With other equipment, you might simply place it on a suitable coloured piece of cardboard or plastic. But it is not always as simple as that.

Three-dimensional objects, which tend to roll away, can be adjusted with small lumps of modelling clay. But this should not be used with leather, cloth or similar materials, because a prolonged application of modelling clay can result in greasy patches. In such cases, it sometimes works to wrap the clay in a small piece of clear film (for wrapping food). It then loses its adhesive prop-

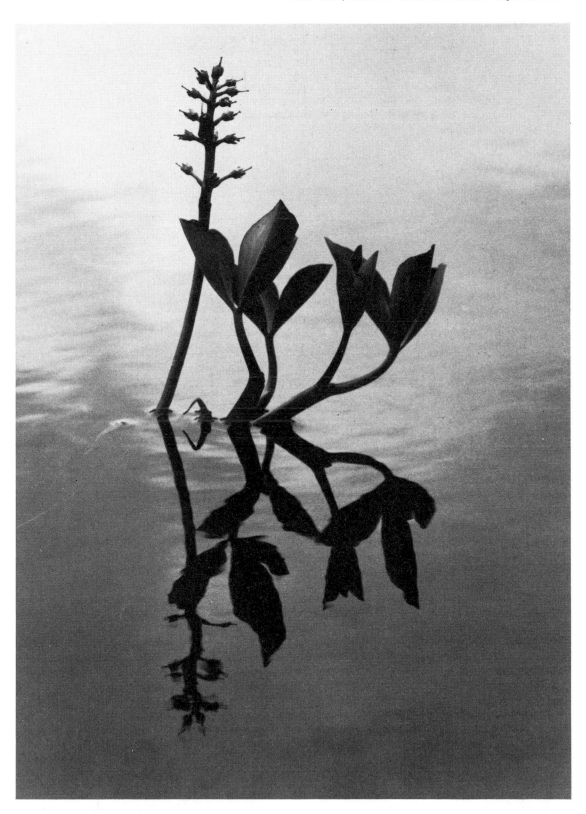

69 Insects are usually 'hunted' with a hand-held camera (as was this caterpillar). A shooting angle parallel to the subject can accommodate it within the available depth of field. Magn. 0.4 X, *f*/16, 100mm macro lens, hand-held camera.

erty, but still acts as a support.

It is often very difficult to manoeuvre very small subjects into a 'photogenic' position. Here insect mounts come in handy. They are small stands with ball joints and clamps, which are either fitted with a cork end, to which you can fasten your subject (ie. insects) with needles, or with crocodile clips, which you might find to be more versatile.

Things like that do not have to be bought. Flexible wire, crocodile clips of various sizes (bought in a ham radio store) and plaster of Paris (for the base of the stands) are the most versatile materials as supports for the subject. They are, in fact, better than those you buy because you can construct them to your own specifications.

Apart from this, some kinds of lenses make admirable stands for subjects. Many macro lenses are constructed so that the front lens element does not rotate when you turn the focusing ring. You can place them upside down on a table and the subject on the front or rear lens cap. You may then use the focus travel of the lens to provide continuous adjustment of the height of the subject.

I frequently use an arrangement of this kind when working outdoors.

Finally, how can you stop subject matter like plants from moving if you can't use windshields of the kind discussed previously? The easiest method is to hold it with a clothes peg (spring clip type) attached to a tripod with a strip of adhesive tape. This, of course, requires a second tripod for the camera. Even so, it is often better to use this arrangement to stop the movement of a plant in the wind and hand hold the camera, rather than have a camera fastened to a tripod and a wildly swaying plant.

Another way to approach it is to attach a clamp-and-wire device to your camera, which allows you to fix the plant at a constant distance from the camera.

But whatever you do, do not cut plants or mutilate them in any way. This is not only very bad manners for a nature photographer, it is a destruction of nature by those of us who should know better.

17 INSECTS AND ANIMALS CLOSE-UP

There are two entirely different ways to 'hunt' small animals with a camera. They require different hardware and a different approach. The first of these is to work with a hand-held camera, looking for locations to 'shoot'. The second is to work with stationary equipment, which implies the choice of a likely spot first. We will discuss both possibilities, starting with the one which is more commonly used.

Shooting with a hand-held camera

The first problem you will have to overcome is that most animals flee when you approach them. The flight distance is peculiar to each species and to each situation, and it varies with the experiences the animal in question has previously had with man. Most species of birds, for example, recognise certain kinds of people. They would fly further away from people with shotguns and dogs than from other local working people.

Birds feeding in unfamiliar surroundings fly further when alarmed than they do in places with which they are very well acquainted, such as the immediate surroundings of the nest.

Other animals, like most insects, do not differentiate in this way, they simply take off (or scuttle away) as soon as they recognise an approaching person as such. The stress here is on 'approaching', because you may remain entirely unnoticed if you do not move at all—which of course is impossible if you work with a hand-held camera. Here are some very simple rules for nature photography: you should not approach wild animals from the same direction as the wind; you should avoid noise and hasty movements; you should not let your shadow fall on animals or insects which do not seem to have noticed you. Apart from these, you have to gain the necessary experience yourself.

But the implications as far as your equipment is concerned are obvious. You need long shooting distances, the longer the better. While it is, for example, relatively easy to photograph spiders, ants and other bugs with a 100mm macro lens (or perhaps even with a 50mm one), this would, at best, work only occasionally with butterflies, dragonflies and others.

In my opinion, the best general equipment for insect photography with a hand-held camera is a 200mm telephoto lens mounted on a bellows unit.

The exact distances and magnifications possible with this, of course, depend on the brand you use. In order to give you an idea of what is possible, I will quote the data of my equipment. My bellows unit can be extended so that a magnification of approximately 0.7 x (1:1.4) is possible, that is, the field covered measures 33 x 50mm at a focusing distance of 0.57m! With this combination it is not possible to reach life size reproduction, but many butterflies, for example, would already be too large to fit comfortably into this field.

Because you do not need a focusing rail for a hand-held camera the unit can be fairly small and light. An additional bonus of the relatively large focusing distances involved is that computer flash units will work reliably, so that you only have to correct the aperture (in the case of my equipment, the difference is approximately 1½ stops).

In order to be really quick, you should not bother with focusing. Pre-set your equipment to the magnification you are likely to need and adjust the camera-to-subject distance accordingly.

It is a good idea to practise focusing in this way first, so that you do not have to move around too much when trying to find the right distance. A shoulder grip might help you keep the camera steady, or winding the camera strap around your wrist and tightening it against the body.

When you are more interested in small mammals and birds the equipment described above is not ideal for hand-held photography because you need still greater shooting distances but smaller magnifications. In this case, the best possible equipment would be a 400mm or 600mm follow-focus lens, as previously described, otherwise a lens with the minimum possible focus travel.

Using mounted cameras

Fortunately, many animals have very predictable habits. Many butterflies prefer certain plants for feeding, ants have 'roads' on which they move, birds have places to which they return time and again to feed and they also have nests and mating grounds. Even the notoriously fast and elusive dragonflies follow certain flight patterns and return to the same resting place.

It is the nature photographer's duty to know these things, or to find them out. You can do so by watching animals and gaining experience or by consulting good books *and* gaining the necessary

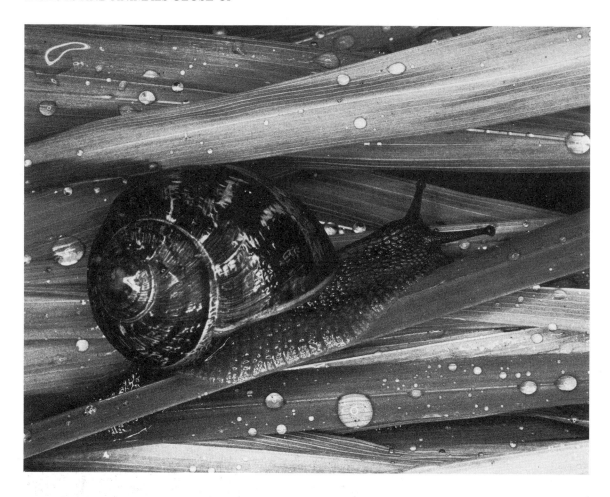

experience. If you do not know the behaviour patterns of the animals you want to photograph you can anticipate what they are going to do, so that you can set up your camera in a particular place and simply wait for developments.

Suppose, for example, that you want to take pictures of wasps. You could look for rotting fruit, which wasps like, a bunch of grapes, an apple or something similar.

You can set up your tripod, mount the camera (with a bellows unit, a 50mm macro lens, etc), focus, arrange the lighting and so on in advance. The rest is simply a question of patience, because sooner or later a wasp is going to come (provided that there are any, which you should have checked previously).

When working in this way, a long cable release and an automatic camera with a winder or motor come in handy, so that you don't have to come near when the action starts. Then long focusing distances are not important and you can use all

kinds of lenses.

Most of today's cameras can be connected to remote triggering devices such as light barriers (or with larger mammals, step-on contacts) in a completely automatic mode. The light barrier is arranged to coincide with the pre-set plane of focus of the camera lens.

Some photographers I know delight in extremely complicated devices which they use to take very unusual photographs. It is—to quote only one example—perfectly possible to capture nocturnal moths in flight. All you need is equipment for life size reproduction mounted on a tripod and connected to one or two flash units and a light barrier which triggers the flash when a moving object crosses it. Additionally, you have to set up a light source, preferably emitting ultraviolet light, which attracts the moths.

From there on it is a question of patience and a generous film supply until you succeed—which may easily take a few years. I do not say this in

70 The snail may not be the fastest-moving creature but it can call for patience to catch him in the right place. The easiest way to work is to follow him with a hand-held camera. Unless you are to use available light, or you are seeking some special lighting quality, the most convenient alternative is a ring flash.

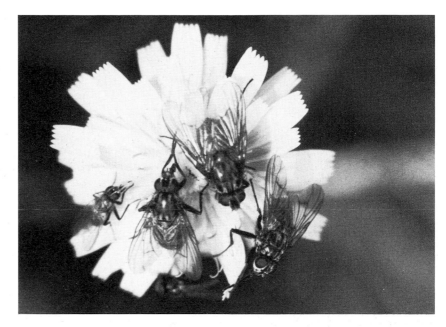

71 A bloom 'loaded' with a bit of honey will result in a lot of action. The problem is to apply the honey (or jam) so that it won't show on the surface and therefore in the photograph. The solution here is to use a discarded hypodermic syringe. Magn. 0.7 X, 100mm lens with auxiliary close-up lens on bellows unit, focusing rail, tripod. *f*/16, 1/60 sec, flash.

72 This photograph shows an exceedingly small spider (Theridion pallens, less than 2mm in size) with its cocoon. The female spider 'glues' its cocoon to the underside of oak leaves. If you detach the leaf and turn it upside down, the spider will very soon appear in order to remove the cocoon to what now is the lower side of the leaf. Magn. 6 X, 25mm special macro lens (Photar) on bellows unit, focusing rail, stand, *f*/4, 1/60 sec, flash plus white cardboard reflector, camera with angle viewfinder.

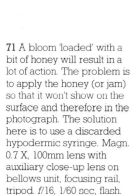

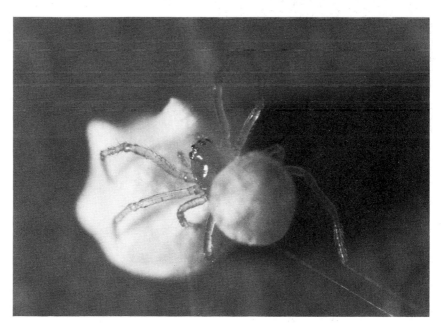

order to deter you from trying, I simply want to point out that it is very difficult and requires an enormous amount of patience to do something really outstanding and remarkable in this field.

It is not only your presence which might frighten away animals, but noise, or the light of your flash. Even a camera on remote control may not allow you more than one shot because of the clicking of the shutter and the whirr of the winder.

There is very little you can do about this. On the contrary, if you repeat your performance too often, you may frighten the animals so much that they change their habits and do not return at all.

This mainly applies to mammals and birds. In my experience insects are not so finicky.

Making an artificial environment
In may respects it is easier to photograph animals

in an artificial environment, which you can arrange and control. If you, or your children, keep mice, hamsters, rats, turtles, snails, frogs or other animals, you could make a start with those. The problem here is to place these animals in an environment which, on the one hand, looks natural and, on the other, prevents their escape. In order to be successful at this game, you have to know precisely how and where these animals live. You may have to collect plants, earth, stones, bark and so on and arrange them in a still-life which contrives to look natural and at the same time hides glass, wires or the other confining features of your 'habitat'. If the animals which you photograph are not very quick and tame, you could provide this enclosed area with a hinged wire front that you can remove for taking pictures. If this is not possible you may have to shoot through a sheet of glass.

This should be absolutely clean and free from optical faults. Plate or float glass is suitable. The way to avoid reflections is explained under the next heading where we discuss aquaria.

Smaller animals, and especially insects, are easier to photograph because often a twig with a few leaves is the only environment you need. Flying insects have to be kept in cages of very fine wire mesh and with one side made of glass.

When working in this way you must remember that many light sources emit heat, under which your 'models' may suffer or even die. Too much heat will, at the very least, lead to unnatural behaviour, which should be avoided—and please remember that you are dealing with living things.

Very small flightless insects (ant-sized, for example) can be confined by arranging their environment on an upturned plate placed in a tray or dish filled with water, thus forming an 'island'.

Although most animals will resent your treatment and therefore behave unnaturally, in most cases they will calm down after a while and resume their natural actions (like feeding, if you have thoughtfully provided something for them). You should wait until then before you start taking pictures.

It is most fascinating to watch a butterfly turning from an egg into a caterpillar, then into a chrysalis and finally into the winged insect. If you want to see and photograph this development, you will have to start by collecting the eggs. Those of the Cabbage White (Large White) butterfly, for example, can be found on the undersides of cabbage leaves. They look like very small yellow

pearls, a little over 1mm long. In order to breed these you simply need a fresh cabbage leaf now and then. After the caterpillars have hatched, about three weeks pass before they turn into chrysalides. They remain in this state for another three weeks. When you can see their yellow wings beneath the surface of the chrysalides, you have to act quickly in order to catch the moment when each chrysalis starts to break open. The whole process of the emergence of the butterfly and drying of the wings may take anything from a few minutes to an hour or more.

The eggs of the more exotic butterflies and those of other insects as well can often be bought from suppliers of zoological materials or from entomologists. But before you engage in this kind of activity you should make sure that you can raise these insects and have access to their food which, after all, may be some rare and expensive plant.

Working 'underwater'—the aquarium

In my youth, which is not as long ago as I sometimes think, pools, ditches, lakes and even puddles teemed with life of all kinds and descriptions. Nowadays you often find nothing but rusty tins, old shoes, oil and other even less inviting things. Nevertheless, you can still find pools which contain small fish, insects, snails, plants and so on in abundance. It is not possible to photograph these underwater as you could in the sea (which is a very specialised subject and will not be discussed here) but you have to catch them and photograph them at home in an aquarium.

Other subjects to be photographed in an aquarium are, of course, the (usually more exotic) fish and plants which cannot be found in your own seas and rivers.

You can use the normal type of glass aquarium. The clear plastic type is not so good, because it may distort the image. But for smaller creatures you need a special small tank or container, sometimes known as a photographic cuvette. They can be bought but are hard to find and relatively expensive, so it is probably much simpler to make one yourself. Fig 19 shows some ways in which this can be done. The glass should be 2mm thick picture glass, slide glasses for microscopes or the cover glass from slide frames. As glue you either have to use special silicon glass glue, or you can improvise with a two-component glue.

Normal aquaria or the larger home-made variety can be partitioned off with a sheet of glass, in order to restrict the movement of the subjects to

Fig 19 Two photographic couvettes for 'underwater' photography. **A** is for small fish and animals. **B** can be used for larvae and other very small living subjects. The larger model is made from five pieces of thin glass glued together with two-component adhesive. The smaller consists of two sheets of glass from a 6 x 6cm slide frame separated by three strips of wood glued together on three sides.

the area covered by the available depth of field.

Behind the far side of the aquarium you can fasten a green or blue sheet of paper which serves as a background. Naturally, an aquarium which most closely imitates the natural habitat of the subjects to be photographed is best.

The main problem with lighting is to avoid reflections in the glass. Reflections of the surrounding room and your equipment do not show if you work in a darkened room and you place a large sheet of black cardboard in front of your camera (with a hole cut out for the lens!)

The light sources themselves will not produce any visible reflections in the glass if you position them at an angle of 45° to 50° to the front glass of the aquarium. This, however, will result in a loss of light of approximately 50 per cent, but that can be corrected by dividing the flash-to-subject distance which you would normally wish to use by a factor of 1.4. (For example: flash-to-subject distance normally used for a given magnification: 0.45cm. Divided by 1.4=0.32cm. Accordingly, you reposition your flash unit at this distance without changing anything else.)

If you frame your subject so that the background does not show, it is a good idea to exchange the green or blue background for a sheet of white cardboard. This helps to distribute the light more evenly and reduces contrast.

Some small fish and insects (like the larvae of gnats) are so transparent that it is possible to see and photograph their inner organs. This is best done with backlight or, even better, using dark-field illumination. If you use a home made cuvette of the kind shown in the diagram, this is relatively simple because it can be inserted in a hole cut in a thick sheet of black cardboard, behind which you place your light source.

The heat of the light here becomes a double problem because you may not only boil your specimens, but suffocate them as well, the reason being that warm water contains less oxygen then cold water.

To catch a specimen is a science all by itself and is explained in the appropriate books. The advice given there should be extended by the admonition to return all animals to the place where you found them, when you have finished with them.

Finally, I would like to draw your attention to a combination of aquarium and terrarium (usually called a paludarium) which could house all animals normally living in the marshy border between land and water. This is a habitat especially rich in specimens and worth exploring although some care is required in the preparation of the paludarium. If you expect any degree of success in this kind of photography you should have some books on the maintenance of aquaria, plants and animals because it is not enough simply to know about the photographic side of things.

Domestic animals

Pet animals are admirable subjects for close-up photography because they are usually quite tame. Full-figure 'portraits' of cats and smaller dogs fall naturally within the close-up range. Heads, even smaller details (eyes, for example) and full-figure pictures of hamsters, mice, pet birds and other creatures offer a good training ground for similar wildlife work.

The cages for captive animals are often dull and sometimes downright ugly, not only from the animal's point of view—the animal is, after all, accustomed to a specific environment—but from a photographic viewpoint as well. If you bother to find out how your animals would normally live when free you should be able to imitate their

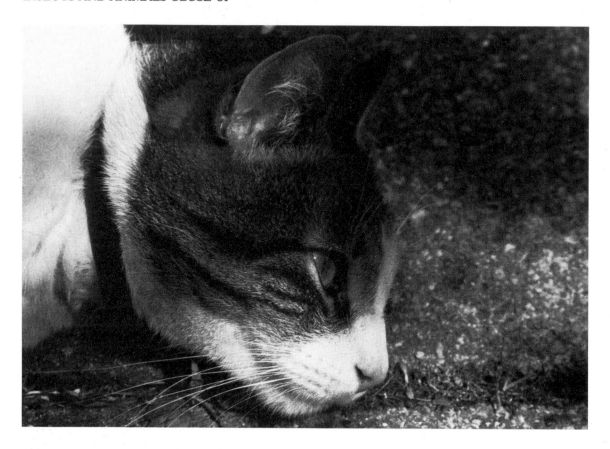

natural habitat in a convincing way. You may see them less often, compared with keeping them in a bare box or wire cage, but if and when you do, the enjoyment will be greater and the photographs decidedly better.

When photographing small animals like mice or hamsters you need magnifications of 0.2 x or greater. Here the depth of field is so small that parts of the animal will be out of focus—whiskers, for example. In most cases it is best to focus on the eyes if you are not looking for some out-of-the-way effects.

If you keep a pair of animals, it would be interesting and rewarding to build up a photo series covering all aspects of the animals' lives from mating to the fully grown stage. This is, of course, a long-term project, and may easily require the lifetimes of several individual animals before it can be successfully completed.

73 Cat in action. It can be difficult to find an unusual angle on such a well-worn subject as the domestic cat. Provided with something to creep up on, however, it is possible to produce an 'active' rather than a 'passive' close-up picture.

74 The beauty of contrasts in nature can provide the means to a good picture. The delicate wings of the butterfly seem even more so when compared with jagged twigs that resemble barbed wire — an opportunity grasped with a hand-held camera and 200mm lens.

75 The dragonfly was not taken by flash, despite the considerable depth of field in this picture, but in direct sunlight with a hand-held camera — showing what it is possible to achieve without resorting to artificial light or special camera supports.

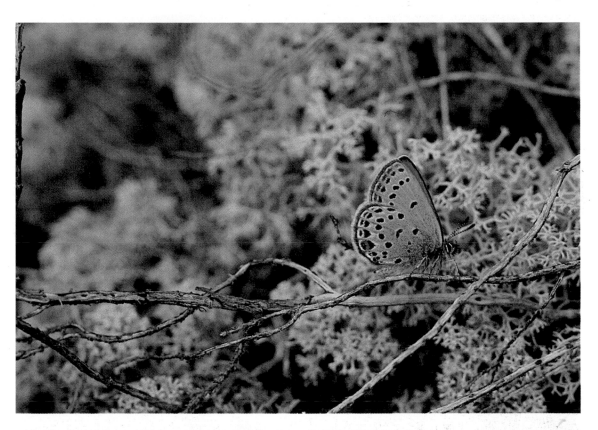

76 Racoon, fishing. In a natural environment only a telephoto lens, good natural cover, much patience and a little luck will be rewarded with a picture of such quality. Subjects of this scale are within the reach of a photographer armed with a 200mm lens. But it is better to err on the short side — you can lose pictures by fitting too long a lens.

77 Shallow depth of field here forces attention on the frog's head and, in particular, on the eye. The opposite to a documentary treatment, what this approach loses in recorded detail it seems to gain in drama and life.

78 When photographing small animals and insects it is important, in the excitement of getting in close, not to overlook the context. In many cases a better composition will come about by including a significant part of the surroundings as well, particularly where some activity is involved, as with this spider.

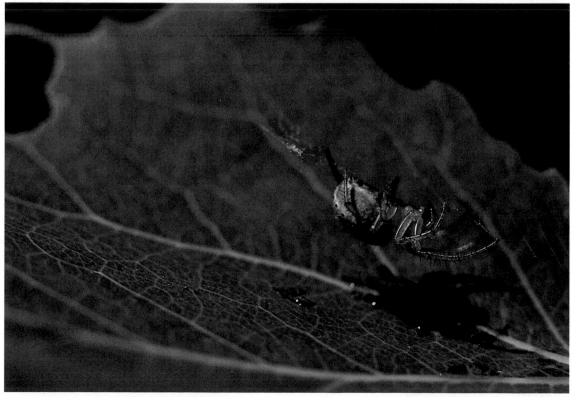

18 FLOWERS AND PLANTS

The close-up photography of plants can be roughly divided into three categories. First, outdoor work, where you photograph plants in their natural environments, botanical gardens and so on. Second, plants in hothouses, and third, plant photography at home or in the studio.

Each of these requires a slightly different approach and different equipment. Additionally, plants can range in size from giant sequoias to monocellular organisms, which calls for equipment that is versatile as well.

Photographing plants outdoors

When taking pictures of plants all you may need is a simple close-up lens or a macro lens, because many plants are so large that they do not require great magnifications. Even their details like leaves or blooms are often large enough to be photographed without sophisticated equipment. The main problems here are the lighting and the background.

Especially in woods, you often have crisscrossing patterns of shadows thrown by branches or other plants. These would destroy a picture so you either have to wait for a change in the lighting or use flash. The latter is not usually a good solution because it will result in inky backgrounds.

If you do not want to show the plant in its natural surroundings or if this is too confusing due to an abundance of other plants, it is a good idea to use a green or grey piece of cardboard as a background (the latter suffices for black and white photography). Some people prefer a finely textured cloth which can be rolled and thus carried more easily than cardboard. But it must be carried rolled or in one piece to avoid creases.

In situations like these you may feel you should use flash because the black background that you would normally wish to avoid in this case serves to isolate the plant from the confusion that lies beyond. This method is often used in documentary work. But although the plant is shown quite clearly, the picture will generally not be very convincing from the viewpoint of creative photography.

If you want to photograph only details of plants, the background is usually a negligible factor. Against this, even a slight breeze can be enough to prevent you from focusing properly. It may be of no avail to mount the camera on a tripod but it can help, as something to fasten the plant to, as previously described. A walking stick or stake can serve the same purpose, leaving your tripod free to be used for the camera. Smaller plants can be protected against the wind by portable windshields.

Some plants have a surprisingly long range of contrast. Crevices in tree-bark or holes or recesses under roots, can be almost entirely black and shadows on dark surfaces tend to be inky as well. The solution to this is to use a white cardboard or crumpled aluminium foil reflector to serve as a secondary diffused light source.

When you work in colour you might sometimes have problems with green colour casts in densely wooded or otherwise overgrown areas. Here, colour correction filters like the Kodak CC10M or CC20M come in handy.

But it should be noted that this green hue sometimes adds to the tone of the picture and should then be left as it is.

When working in a broadleaf wood you should take advantage of early springtime, before the leaves are out. The light on the forest floor is then best and many small plants are already in flower or have started to bud.

Photographing these and other subjects close to the ground requires a low-level camera support and angled viewfinder. It is also prudent to carry a sheet of plastic on which you can kneel or even lie down whatever the situation may require.

If you want to photograph flowers in bloom you will run into a particular problem when working with available light. The most interesting view of a bloom may be head-on to the open front side. However, this side is often directed towards the sun so you tend to throw your own shadow across it if you try to take a picture from this angle.

In order to avoid this you could attach the flower to your tripod and turn it in a slightly different direction without breaking it, of course, or otherwise damaging it. But then it may be partly

79 The part may offer a better picture design than the whole. Particularly with plants, look out for the possibilities of making more interesting pictures by selecting certain areas and creating compositions with a form of their own, independent of the plant itself.

obscured by its own shadow, which would create new problems.

The best thing would be to work with equipment offering increased shooting distances, like the 200mm lens and bellows unit combination described earlier, because then it would be less noticeable if your picture is taken slightly off-axis.

Finally I should mention that it is, of course, a good thing to know in advance when and where flowers are expected to grow and/or bloom. This information can be found in popular botanical books.

Hothouse plants

The trouble with hothouses is that authorities in charge of them are frequently over-sensitive as far as photography is concerned. Often you are forbidden to use a tripod or flash, for example. But in most towns there are private people who collect and cultivate orchids or cacti or other exotic plants. If you contact your national or local horticultural society or specialist plant growers the addresses of such people can usually be obtained, if you explain your intentions. It would

80 Although tastes vary, I think it is safe to say that outdoor plant photography should be the domain of available light work — at least, with the exception of documentary pictures, where the mood created by the natural daylight is irrelevant. Magn. 0.5 X, f/22, 1/125 sec, 50mm macro lens, hand-held camera, available light.

81 Although plant photography is usually done in colour, some plants also make very striking subjects for black-and-white work. This is especially true for those with simple forms which can serve to create bold compositions. Examples can be seen elsewhere in this book. Magn. 0.9 X, f/11, 1/60 sec, 100mm macro lens on hand-held camera, available light.

probably help to offer a few prints or slides as a kind of return favour if you ask permission to photograph their collection.

In any case, whether you work in a public or private hothouse, you should have everything ready and organised beforehand in order to make the least possible fuss.

If electricity is available the best possible light source would be a coldlight projector with fibre optics (page 75), otherwise flash. With a single flash unit, a white cardboard reflector should be

used to reduce contrast by filling in the shadow areas. Otherwise two flash units can be employed as described earlier (Chapter 16). When working in a restricted space, it is an advantage to have a tripod to which (optional) brackets can be attached, so that camera and light are mounted on just one tripod.

If flowers are kept in individual pots, it is possible to turn, raise and lower them in order to obtain a better view. When working in a private hothouse it is a very good idea to have that done by the proprietor to avoid any question of your being responsible for damaging a rare specimen, for example.

Plants in the home or studio

Everything I have said concerning photography in hothouses applies equally when you are working at home. But there you have greater freedom and the plants are usually your own, so you are free to experiment.

This applies, for example, to the lighting. It is even possible to use normal floodlights because it is up to you whether or not you are going to ruin your plants by the heat.

Cut flowers wilt very quickly, or at least move in strong light and heat, so you should be very careful with your lights. Switch them off, even if you stop working only for a short time and use only one lamp for focusing. Lamps provided with dimmers work best, because you can 'build-up' the lighting effect in low light and use full power for the actual exposure only.

At home, working with your own flowers, you can arrange special effects which would not be possible elsewhere. It is, for example, very interesting to remove parts of the outer petals of a bloom, or all of them, and to photograph the interior structure in what you might call a 'bee's eye view'.

Some blooms have petals so delicate that it is worthwhile experimenting with strong backlight (or dark-field lighting) which can bring out their structure in a transparent image. Often backlight adds to the impact of a bloom because it adds a certain glow to its colours, even if it is not transparent.

Thin leaves and small blooms become trans-

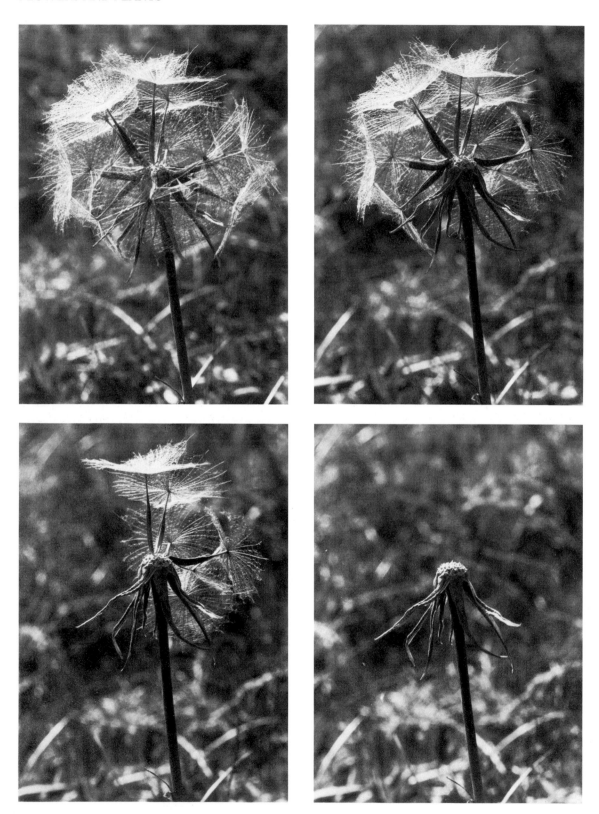

parent if you immerse them in potash lye or in a weak solution of nitric acid. The process, which might take a few days, renders the plants very transparent. But they become so fragile that it is impossible to remove them from the solution, so this should be done in a photographic cuvette or a small aquarium.

If this proceedure is not to your taste, you might simply try to place the flower heads on a frosted screen. A surprising number of them will yield transparent pictures without further ado.

Recording plant growth

Another thing which can only be done at home is to record a series of photographs showing the growth of plants, the opening of their blooms and other stages. This kind of work requires some preparation. First of all, you must have some idea of how long the process to be recorded is going to take. The blooms of some flowers, for example, take less than an hour to unfold, while others may take a whole day. Additionally, you should take into account that the blossom or other subject to be photographed may change position or grow during the process. When arranging the framing of the picture you should leave enough room for this from the first picture you take because a series looks best if you do not change the framing, magnification or lighting between individual pictures.

This obviously implies that you need a space where you can leave your subject, camera and lighting arrangement for the time required.

Finally, you have to decide whether you want to record the process on separate frames or as a multiple exposure. The latter requires a completely black background. It offers interesting possibilities when extremes of movement, displacement of parts, or changes in size can be expected. The determination of exposure for these multiple exposures follows the same rules as in general photography.

The most elegant way to make serial pictures is with an intervalometer which can be set to the time intervals needed and, together with an auto winder, does the whole process automatically— shooting, operating the flash or lighting and winding on the film at pre-determined intervals. Professional equipment of this kind is quite expensive, but some camera manufacturers offer simpler versions as accessories. If your camera shutter is electronically triggered, you could as an alternative use the kind of intervalometer produced by some Super-8 camera manufacturers. Although intended for moviemaking, these accessories work just as well with still cameras.

But it is equally possible to do everything by hand, the only requirement being that you stick scrupulously to the intervals, on which you have decided beforehand.

Another interesting range of subject matter is fruit and seeds, which not only look interesting from the outside but may reveal fascinating interior structures when cut in half or otherwise opened. The skin of a fresh pineapple, for example, has a very interesting exterior, but if you cut it off and carefully scrub out the remaining fruit pulp, you will really be surprised! (Many exotic fruits make interesting subjects and you can eat them afterwards as well!)

Ligneous fruit and seeds (like nutmeg) reveal their interior structure when sawn in half and carefully polished. Sometimes it helps to laquer surfaces as well.

By these few ideas given here you can already see that plant photography is really much more than taking the occasional flower now and then. If you look around you, you will find many more possibilities.

82 A-D Most picture sequences are created under studio conditions. But sometimes an opportunity offers itself to make a series outdoors — these photographs being a very obvious case in point. Magn. 0.3 X, *f*16, 1/250 sec, 100mm macro lens, hand-held camera, available light, wind shield.

19 COPYING AND REPRODUCTION

Professional copying is done with lenses of relatively long focal lengths designed for flat-field subject matter at close range, in order to obtain the best possible image quality.

In general, longer focal lengths are best for this purpose, but when copying originals of A4 size or larger, this may pose quite a problem, because the columns of most available copying stands are not long enough for the purpose. A 100mm macro lens would be the best choice but if image quality is not of the very first importance some other lens may do as well. For example, many 28mm lenses can be focused down to 0.3m, giving a magnification of approximately 0.14 x, which would cover the size of an A4 original. The reproduction of a typewritten or newspaper-type original with a lens of this kind would certainly be legible (provided that you have a good lens) but the edges and corners of the reproduction would probably show less quality.

Lining up

The next problem to be solved is the camera set-up, which should be done so that the negative plane is absolutely parallel to the surface of the original. This is not so easy to achieve. Even a spirit level may not help because the standard versions are not sufficiently exact for use with short sections such as the back of a 35mm camera.

The best way to secure alignment of the camera is to use a simple, flat mirror. You should use the glass only, so that the surface of the mirror is truly parallel with the original to be reproduced (this is not always true for framed mirrors).

With a vertical copying set-up, the method is simply as follows: you place the mirror under the camera on the original. Then you look through the viewfinder and focus on the mirror image of the lens. If the image of the lens can be seen exactly in the centre of the focusing screen the camera is properly aligned. Check this by comparing the position of the image with the round microprism spot or other features of your screen.

Lighting the subject

Next, we have to deal with the problem of illumination, which is actually quite straightforward, because the only relevant condition for good copying light is that it should be entirely even. If necessary, this can be improvised with one light source only, provided that the original to be reproduced is not too large.

In the case of one lamp, the light source should be placed at an angle of 45° at a minimum range of at least 6 x the width of the original. If you do this in accordance with Fig 20A, the lighting will be tolerably even.

But it is, of course, much better to use the 'classical' four light illumination with tungsten lamps (with flash two units would be sufficient, one on either side). The correct set-up is shown in the second part of Fig 20B. If you are in doubt as to whether you have really succeeded in producing even illumination, you can do a simple test by placing a pencil or similar object upright in the middle of the original. It is easy to check visually whether the four shadows (or two, with a two light set-up) are of equal density.

Film and colour quality

As long as you are shooting in black and white, the colour temperature is of no consequence. But for colour reproductions with slides you have to use daylight-type film for tungsten illumination. When working with colour you should not use dimmers with your tungsten lamps because this would result in a shift of colour temperature that would be very difficult to control.

Whatever film you use it is a good idea to make at least one exposure of a grey-and-colour-scale test chart under the same conditions and on the same film as the reproduction as a check for any colour bias. If you make enlargements, or have them made, this offers a point of reference even if the original is no longer available.

Continuous tone originals (whether in colour or black and white) which are to be reproduced in black and white should be taken with monochrome films of the ASA 50 or 100 type. Use normal development, except for very contrasty originals. Monochrome continuous tone originals can just as well be reproduced on orthochromatic film if available for your camera. This is developed for continuous tone with one of the special developers available for document work.

Line originals (strictly black and white) should be reproduced on a high contrast copying or a slow speed conventional material, developed for contrast. Best results would be obtained with a special lith material processed in a developer for-

Fig 20 Copying and reproduction. **A** If only one light source is available the distance between that light and the original must be at least six times the width of the original. **B** The optimal set up for the reproduction of flat originals is with four identical light sources equidistant from, and at 45° to, the surface of the original.

mulated for the purpose, but this is usually only available in the form of sheet film. For continuous tone originals (monochrome as well as colour) the built-in light meter of your camera can be used. But for line originals the most reliable way to determine exposure is to use an incident light meter. If you do not have one you should either make several test exposures across the film (when working with sheet film) or bracket your exposure (with 35mm or roll film). Suitable exposures for predominantly white originals will be, in any case, in the order of 2–3 stops greater than those indicated by the exposure meter.

Texture and reflections

Yellow or brown stains in the original can be made invisible or at least reduced by using a yellow or orange filter, which of course works only with monochrome originals and films.

Some additional problems have to be solved when you want to reproduce originals with a textured surface (like paintings, gravures or shallow-reliefs). If the texture is to be suppressed as much as possible, you will have to use some form of shadowless lighting such as those discussed earlier.

The copy lighting described above will provide very soft shadows, but if the texture is to

show clearly, it would be advisable to use a modified set-up with only one light source and a white cardboard reflector positioned on the other side in place of the second lamp, to reduce contrast. In the case of colour reproduction the white reflector must be really white, otherwise it would throw a colour cast over the original.

Highlights on glossy textured surfaces are usually undesirable in reproductions. The first remedy for their removal should be adjustment of the lamps. Otherwise, a polarising filter placed over the lens helps to reduce them (on non-metallic surfaces). But often it is necessary to place polarising filters over the light sources as well. For this application sheet filters can be used. Reflections and highlights on metallic surfaces can be reduced by placing them under water, for example in a wide glass bowl or in a developing dish. Great care should be taken to ensure beforehand that the original to be treated in this way does not contain parts which may be damaged in the process.

Copyright
Before discussing next the copying of slides and negatives, I should probably point out that reproducing (and using) an original may easily turn into an unlawful occupation, due to infringements of the copyright laws of your country.

These copyright laws differ from country to country but the gist of them is generally that the right to copy originals and to use these copies (for example, for publication or to illustrate talks and so on) either belongs to the owner of the original, to its originator or to his/her heirs for a specified period of time. Original works of art which are in your possession can usually be reproduced as you like. If you intend to make reproductions and use them publicly in some way or other you should make sure beforehand that you do not infringe any copyrights. In most countries there are no restrictions on reproductions intended for your personal use only.

Provided that it is legally permissible, you might want to make reproductions of books or documents in libraries, where you cannot set up bulky and complicated copying stands. I do not know how spies do it, but for cases of this kind some manufacturers offer 'copy legs' for their cameras, which are simply mounted on the lens. These attachments are easy to use because they keep the camera at the required height, in proper alignment and at the same time define the field of view (either with a wire frame or simply by the outer edges of their legs).

Copying slides and negatives
For the purposes of copying or duplicating slides and negatives you can either use a slide copying attachment, which is available as an accessory for most bellows units, or a special slide copier. Most of the latter type are intended for professional or commercial use and are quite expensive. But at the time of writing there exists at least one moderately priced but nevertheless quite useful unit of this kind which has been specifically designed for amateur use. The main difference here lies in the fact that the more advanced instruments of this kind have a device to control the contrast of the duplicates.

On the other hand, you can easily construct an improvised slide copier yourself. All you need is a piece of black cardboard with a hole cut in it, over which you can position your slides, fastened with adhesive tape. A matt diffusing screen must be placed behind the cardboard. Instead of the matt screen it is possible to use one or two sheets of tracing paper, or frosted plastic film, or opal plastic. It should not, however, be in direct contact with the slide, particularly if the diffuser has a granular surface, or the grain or marks on the diffuser will be reproduced in the copy slide.

Whether you use a slide copying attachment or a home-made unit, you will need an external light source, either a tungsten lamp, or—much better—a flash unit. The reflector of the flash unit is pointed directly at the matt screen (or tracing paper) and the intensity of the light is controlled by moving it closer to or further from the camera.

It is necessary first to shoot a test film in order to determine the exact position for your lights with your set-up. You can note this down for future use.

For your guidance, I will quote the values for my equipment. The chances are that they will be somewhere near those needed for yours, so that you are not completely at sea when making your first test run.

With same-size reproduction and film of ASA 50, the distance between the reflector of the flash and the opal screen of my slide copying attachment equals the guide number (in cm) of the flash used at $f/16$. This means that a flash unit with a guide number of 28 (for ASA 50) should be placed 28cm away from the matt screen. (Computerised flash units have to be used in the manual mode.)

83 The original negative for this illustration was reproduced with 2 X magnification (original neg. ASA 400 — second neg. ASA 100). The film was developed for contrast and to bring out the grain. A second, positive 'negative' was made from this. The second negative was used for this enlargement, resulting in a negative image. Magn. 2 X, *f*/8, 1 sec, 50mm macro lens on bellows, camera with focusing rail and angle viewfinder on copying stand. Transillumination with slide duplicator.

When working with flash, you need an additional tungsten light source for focusing and framing purposes. A 60 or 100 watt lamp would do, but do not place it too close to your flash unit, which could be damaged by the heat if you used it for a lengthy period.

You do not have to switch the tungsten light off during exposure. Compared to the intensity of the flash light it is too weak to influence the result in any way. Colour correction filters or special filters for creative application of colour can be placed between the light source and the matt screen or in front of the lens, depending on what your set-up permits. Special slide duplicators usually have built-in filter holders.

Special effect attachments like multi-image prisms, rainbow filters and similar items of course have to be placed over the lens.

When duplicating slides, the choice of film is an important matter. There are special slide-duplicating films but they come only in rolls of 10m or longer, which does not suit everyone's needs. When using normal films for slide duplication, you should always use a film for the duplication which

is different from the original. For example, if you made the initial exposure on Agfachrome, then the duplicate should be made on Kodachrome or Ektachrome—or the other way round. The reason for this is that each film stresses some colours in favour of others. With duplication, these weaknesses tend to accumulate if the same film is used for both original and copy.

The second problem is the increase in contrast which you cannot influence in any way without a special duplicating machine.

Selecting and modifying images

Apart from simply copying an existing slide there are various other interesting processes which may lead to entirely new and fascinating images.

The first of these is to reproduce only a very small part of the original slide with very high magnifications. At magnifications of 25 x or greater for originals photographed on ASA 25 to 100 film and magnifications of 15 x or more for high-speed films, the coloured granular structure of the film becomes visible. It forms intricate patterns of irregularly shaped, multicoloured dots, while still depicting the original subject matter.

You can, of course, search existing slides for parts that would be suitable for this kind of reproduction. But the best results are achieved if you specifically photograph them using extreme wide-angle lenses so that what you intend to be the final subject matter forms only a very small part of the first slide.

Other interesting possibilities are multiple exposures and the use of coloured filters and effect lenses. The duplication of sandwiched slides belongs in this category as well. It is also possible to combine slides with monochrome negatives, or parts of them, and with other materials such as transparent foils, coloured liquids, transparent pigments, and so on.

As you can already see from these few suggestions, slide duplication offers wide scope to your creative ingenuity. But the same is true for the duplication and reproduction of monochrome films as well.

Re-photographing negatives

Re-photographing a negative on monochrome film results in a 'negative' which has a positive image of very low contrast. There is also a monochrome slide film (Agfa Dia-Direct), which, although not designed for the purpose, can be used to duplicate negatives. It has higher contrast

compared to normal monochrome films and should therefore be used only for negatives with low contrast if you are aiming for 'normal' enlargements.

Another possibility is the direct reversal-development of monochrome films and, although a set of chemicals is produced for this purpose, in my opinion the technical quality of this process is inferior to the standard procedure of reproducing the negative twice (which results in a negative as the final stage). I would therefore restrict direct reversal processing to the field of 'photographics'.

But why should it ever be necessary to reproduce negatives? Although cumbersome from a technical point of view the process offers many creative possibilities which are worth investigating.

First, everything which can be done with slides is also possible with monochrome negatives (apart from colour experiments!) Copying a small area of a ASA 400 negative on to another film, for example, results in interesting positive or negative grainy pictures, especially so if the original film was underexposed and overdeveloped. Simply copying a negative as an intermediate stage in producing a print results in a 'negative' enlargement which can be interesting in itself. There are some very famous examples of this technique.

Many more ideas for this kind of work may be found in darkroom manuals but here I will describe only one which you may not know. Very weak, underexposed negatives which are almost hopeless to enlarge, can be reproduced using dark-field lighting. This can result in negatives with normal contrast.

This process is very simple. You have to use a dark-field set-up as described previously, the negative serving as subject matter. The light passes through the transparent parts of the negative which consequently remains dark while it is scattered by the exposed silver grains which are therefore brighter. The negative will look positive in dark-field lighting so the result will be a negative ready for printing.

This works only with very weak negatives of low contrast which must also be free of 'fogging'.

I believe that this field of activities is at least as interesting as that of darkroom manipulations, especially as it is not as widely known and therefore offers a greater number of fresh creative ideas and effects.

84 Close-up subjects may be combined in printing or by re-photographing negatives, slides or prints. Combination prints are easiest to produce when the original images are all in the correct size relationship. Adjustments of this kind can be made when making printing negatives from the various originals or, in some cases when producing a single combined negative.

20 STILL LIFE, MINIATURES AND TABLE TOP

In the previous chapter, we dealt with the photography of flat subjects. Here we will discuss the photography of three-dimensional objects, with the exception of animals and plants, which have already been described in separate chapters.

Collectors' items

There seems to be almost nothing which cannot be, and is not, collected by some person or other. Some collectors photograph their collections for insurance purposes, or to provide information for others. Or, they simply use pieces of their collections as subject matter for creative photographs. If a collection contains items made by the photographer himself, such as small sculptures, painted tin figures etc, instructional pictures to illustrate the process of making them may be very interesting as well.

To reproduce or show flat objects usually poses no problems at all, but three-dimensional subject matter like small sculptures or jewelry can be very difficult to handle because of the small depth of field available. Here it is often better to choose a smaller magnification and to show the main subject as part of a larger set-up. It is a good idea to study advertisements for jewelry in order to gain a general impression of what can be done. You will see that the jewelry itself often occupies only a small part of the overall picture, the rest being covered by draped cloth, pieces of wood, stones, sand, pieces of glass or acrylic glass and other things.

Finding an arrangement which complements and enhances the main subject is a matter of taste—the main point here being the handling surface and structure in monochrome or colour in colour work.

If you want to photograph a series of items it is interesting to show all of them (or at least some if a greater number is involved) in each picture, placing only one item at a time within the depth of field.

In any case the main problem is to reproduce the surface in a way that gives the viewer a feeling of the substance and the surface of your subject matter. These impressions are governed by shadows and highlights, glistening and dull surfaces, and reflections and textures.

Lighting is the principal means of control and in order to obtain impressive results you will have to experiment with direct and diffused light and with combinations of these. This is especially true for metallic objects, which often look unrealistic due to unwanted reflections, surface sheen, white 'empty' highlights and inky shadows. They should be photographed in a darkened room to prevent unwanted reflections, using predominantly soft light, which can be 'modelled' with black cardboard pieces (which show as dark areas on the metal surface) thus adding to the three-dimensional appearance of the subject.

If you do not succeed to your satisfaction, you can use dulling spray, which can be bought at dealers in graphic materials. After spraying, metallic objects appear quite dull and matt. Highlights of varying intensity can then be added by partly removing the dulling spray with a small wad of cotton wool or an old brush.

I must admit that I do not like this procedure because I find the results are not very convincing. But you should try it nevertheless because you may be more adept at handling this kind of spray.

Table top photography

The difference between table top photography and still life is usually defined in something like the following way. Still life is supposed to show things as they are, the creative achievement being in the arrangement and the way in which they are shown. With table top photography, on the other hand, you create new 'worlds' by using models, putting familiar subjects in new contexts or by creating illusions.

It is great fun to create fantastic landscapes out of almost nothing and there are only a few rules which you should take into account.

It is very important that your subject should not throw shadows on the background which are very likely to destroy the effect. Backgrounds should be placed at some distance from the subject and be illuminated by a separate light source. When a continuous blending of foreground and background is desired you have to use a large sheet of cardboard which is gently curved, as shown in Fig 21. With an arrangement of this kind lighting is a bit tricky. Professional photographers sometimes use sheets of acrylic which has a frosted surface. This can be illuminated from the front and the back, the latter method cancelling unwanted shadows.

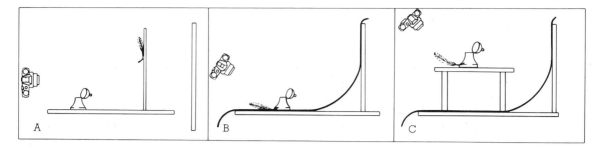

A

B

C

Fig 21 Set-ups for table-top photography. **A** Subject attached to glass background. **B** Subject against seamless paper background. **C** Glass-topped table gives shadowless background.

Floating objects like clouds or aeroplane models can either be placed on sticks or wires which are fastened to the background or can be attached (temporarily) to glass or acrylic sheeting. The problem with the first process is that you must arrange your lighting so that the sticks or wires do not throw shadows on the background, while the problem of the second solution is that the glass or acrylic sheets must be large enough for their borders not to show in the field of view.

A sheet of glass can also be used as the base for a table top. With coloured cardboard or some other surface at some distance below, objects placed on them seem to float in the air. When covered with sand or pulverised paint, lighting from below can add interesting or eerie effects.

Table top photography can of course be used to create the illusion of reality. It is the bread-and-butter work of specialised trick studios and can be seen in many films as well (especially in science fiction, historical and horror movies). But this kind of fake reality is exceedingly expensive and time-consuming to create. Far preferable is the field of fantasy and illusion where much can be done with minimal investment—the only boundary being your imagination. It is a perfect field for people who delight in photography as well as in model-making, sculpture, drawing and so on.

Miniature models

Technically speaking, table top photography and the photography of models are very closely related. The difference lies in the aim, because model photography is usually purely documentary, whether you want to depict existing models like miniature railway landscapes, or you want to create impressions of architectural models.

To photograph models of any size in a bird's-eye view is not difficult. The problem is to give an impression of the model that shows what a model-sized viewer would see because your camera is usually much too large to be inserted, for example, into a model street or between other features. Some special lenses exist that allow this but they are not available commercially.

You can improvise a set-up with a small, front-surfaced mirror, which can be placed almost anywhere in a model at an angle of approximately 45°. If you mount your camera vertically above this mirror you will be able to shoot architectural models from all points of view. You need the long focal length lenses for this process in order not to obscure the illumination of the model with a closely positioned camera.

Because the greatest possible depth of field is desirable, you should use a 35mm camera in preference to one of larger format. For a dedicated specialist in model or table top photography a shift lens or a bellows unit with movements (as described on page 43), though expensive, might be justified for the correction of converging verticals. If you want to photograph models without building them yourself, you should try to contact railway modellers' clubs and similar societies. You will find their addresses in the appropriate monthly magazine. Some of these people even engage in the task of building so-called panoramic models especially designed for photographic purposes—and judging by the pictures you sometimes see published, they would probably welcome an experienced photographer!

The lighting of architectural models in most cases should imitate available light, which is not as easy as you might think, because the sun's rays appear strictly parallel—an effect that you cannot imitate because artificial lights tend to be either a point source or very large in relation to the subject matter, resulting in diffuse light. Moderately diffused light, which throws 'fuzzy' shadows, would be your best bet or, as a second choice, a pointlike light source, placed very far away in

85 This halved sea-shell was placed on a sheet of transparent acrylic. The background consists of a black cloth positioned approximately 30cm below the sheet. The problem with this kind of set-up is the far edge of the sheet, which would show clearly in the background of the picture, if not entirely out of focus. (The nearer border should obviously not be in the field of view at all.) Magn. 0.5 X, *f*/16, 3 sec, 50mm macro lens, tripod, household lamp, white cardboard reflector.

86 A skeletal leaf was exposed four times (with two different magnifications) in front of a dark grey background. You can remove the 'flesh' of leaves by placing them on blotting paper and tapping them carefully and repeatedly with a hard brush. Magn. for two exposures, 0.3 X; the other two exposures, approx. 0.2 X, *f*11; four exposures of 1 sec, 50mm macro lens, camera with focusing rail on copying stand. Two household lamps.

87 Table-top and still-life photographs can be arranged almost anywhere, so you do not have to depend on studio conditions. This photograph shows simple things which can be found at the seaside, grouped together where they were found. Magn. 0.25 X, *f*/16, 1/250 sec, 100mm macro lens, hand-held camera available light.

88 Reflections in the surface of a silver dish. The radiating corrugations are reflecting some colourful wrapping paper laid alongside and lit with a spotlight. Even fractional adjustments of camera angle completely altered the effect.

89 Pure abstract obtained by photographing trails of coloured lacquer in extreme close-up. The picture depends on selecting a suitable area and arranging it as a design — quite easy to do with a sufficiently promising subject — but yielding very pleasing results.

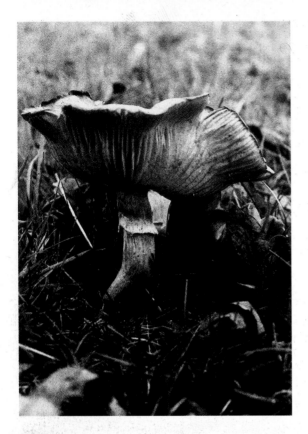

92 Commonplace objects may be combined in pure abstraction or to form a unified design. Close-up subjects lend themselves naturally to this technique as, with them, it is easy to control the background and so isolate the subject in a way that makes subsequent printing easy.

90 A black-and-white print can be treated with tinting medium. A single colour is often more effective than many. The colour can suggest an idea, such as the poisonous nature of a toadstool.

91 An ordinary household object such as this plastic moulded box lid may suggest a design theme for a photograph. Under polarised lighting multicoloured effects can be achieved (page 90).

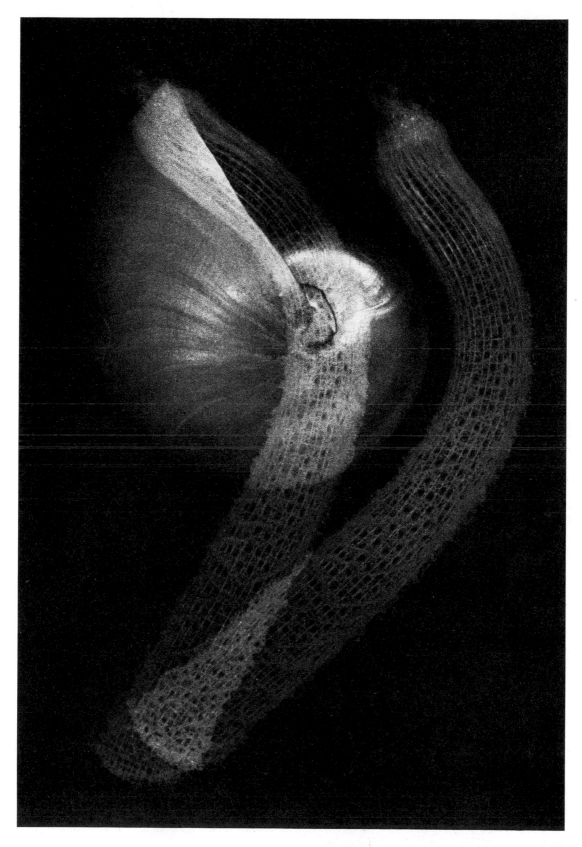

relation to the size of the subject matter so that the curious, trapezoid-like shape of the shadows will be almost unnoticeable.

In any case, you should take great care, because most models consist of highly inflammable materials which should not come into close contact with your lights.

If models do not provide a background by themselves, you can either use a simple grey or blue sheet of cardboard or a large scale photograph showing clouds or a subject related to the motif of the model. The latter can be bought ready-made with a variety of subject matter in hobby shops that specialise in miniature railways.

Still life

With still life photography you have almost complete control over the subject matter and can choose the conditions more or less according to your liking.

You may start by first determining technical values such as depth of field and magnification in relation to the size and extent of your subject matter, then arrange the still life within these limitations and, finally, set up the lighting to suit.

Bear in mind that the subject of your still life is probably not very exciting in itself, but here the challenge is similar to that posed by still life in painting.

The quality of the picture is determined by the ingenuity and originality of your approach, technically and psychologically speaking. An apple is an apple. What you make of it, how you see, interpret and form it into a photograph, are the only deciding factors by which its qualities can be judged.

Because in this process you cannot rely on the originality of the subject matter itself or some element of surprise, still life photography is probably the most difficult category of close-up work to tackle; the more so because these are things which cannot be taught directly.

Abstract compositions

Popularly speaking, abstract close-ups are all pictures whose subject matter is not recognisable to the viewer. They can be derived from almost anything, such as surface structures of living things, unusual technical objects, or common ones seen from an unusual angle or perspective. But it can equally well be a subject that you have specifically created for the purpose, for example, patterns of paint and other substances, swirls of coloured liquids or even smoke, agglomerations of transparent objects and their shadows, or whatever else happens to take your fancy.

The problem here is not the subject, which can be easily found, but the intention behind your photograph. If you want to create pleasing patterns for decorative purposes, for example, it is not difficult. But if you want a photograph to be understood or interpreted by the viewer beyond the 'surface' of its visual elements by a process of association, or in some other way, then you really do have problems which have less to do with the technicalities of photography than the creative imagination.

Photography which is not of the purely documentary or scientific kind should, indeed, *must* have a fair amount of this element because without it it would have very little meaning.

So you should not let yourself be deceived by the fact that in this book we have dealt almost exclusively with technical questions. If you are not a scientist nor have to use photography for documentary purposes, these questions and problems are nothing but the stepping stones to your personal expression.

Technical points can be taught and learned, but you will have to add your own creative personality to the process of making photographs in order to arrive at pictures which are yours and, as such, clearly distinguished from the pictures of others. This is true for all kinds of photography, including close-up work.

93 Finally, we enter the kitchen department, which contains a wide variety of interesting close-up subjects in this case a slice through the centre of a paprika pod, lit with two mini spots and a white cardboard reflector. Magnification 0.3 X, f/22, 4 sec, 50mm standard lens with auxiliary close-up lens on bellows. Camera with focusing rail, mounted on a tripod.

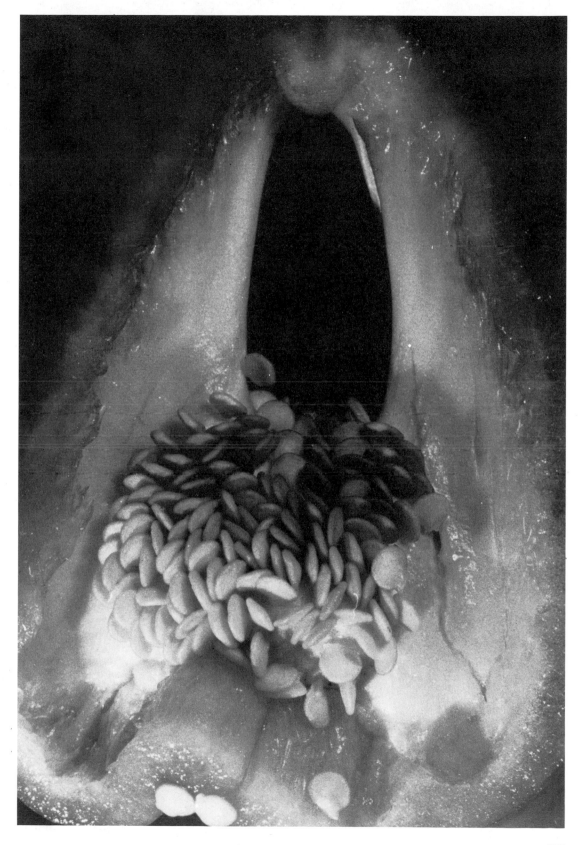

INDEX